Baseball
in New Orleans

BASEBALL
IN NEW ORLEANS

S. Derby Gisclair

ARCADIA
PUBLISHING

Published by Arcadia Publishing
Charleston, South Carolina

Printed in the United States of America

Library of Congress Catalog Card Number: 2003115284

For all general information contact Arcadia Publishing at:
Telephone 843-853-2070
Fax 843-853-0044
E-mail sales@arcadiapublishing.com
For customer service and orders:
Toll-Free 1-888-313-2665

Visit us on the Internet at www.arcadiapublishing.com

CONTENTS

INTRODUCTION

The sporting life has always provided a major source of entertainment in New Orleans. The city's port and rail terminals ensured a constant stream of new and exciting influences. In the years before the Civil War, baseball replaced cricket as the city's most popular participant sport. In July of 1859, the Louisiana Base Ball Club was formed and its seven teams played their games in the fields of the Delachaise estate, then on the outskirts of the city near present-day Louisiana Avenue. As America's population grew through immigration, so did the popularity of what the largest newspaper in New Orleans, the *Daily Picayune*, called "the National Game."

The years following the Civil War saw an incredible expansion of amateur baseball clubs on all levels of New Orleans society. Amateur leagues and teams sprang up across the city—firemen (Screw Guzzles and Red Hots), telegraphers (Morse Base Ball Club), postal workers (Ubiquitous Club), and even cycling clubs (Headers and Anti-Headers). The city's Irish population had a team called the Fenian Base Ball Club; the Germans had the Schneiders, the Laners, and the Landwehrs; the Italians had the Tiro al Bersaglio Society. The early appeal of the game was also exhibited in the African-American community, which sponsored at least five teams—the Orleans, the Dumonts, the Aetnas, the Fischers, and the Unions.

At first games were played inter-club, with the two teams being chosen from among the club's members in much the same way we chose sides on the playground as kids. However, every so often, one club would challenge another to a baseball match. The newspapers would help drum up excitement with advance publicity of the challenge and would report on the outcome. As was tradition, the winner of the best-of-three series would host the losing team at a post-match banquet where the losing team would present a silver baseball to the victors, who would display their trophy prominently in their clubhouse. One such match, between the Pickwick Club and the Louisiana Club, was played in 1885 to promote the Cotton Centennial and Industrial Exposition on the grounds of what is now known as Audubon Park in uptown New Orleans. News reports called this the "social event of the season."

In 1887, nine student athletes from Tulane University played the schools' first baseball game against the Crescent Light Guards. Tulane's baseball program is still going strong, with recent teams gaining national recognition and rankings. Also in 1887 several local businessmen and promoters, led by Toby Hart, secured a franchise in the newly formed Southern League for New Orleans and thus began the city's 73-year love affair with the New Orleans Pelicans. During their reign in the Crescent City, the Pelicans became minor league affiliates of the Cleveland Indians (1930–1939), the St. Louis Cardinals (1940–1942), the Brooklyn Dodgers (1943–1944),

the Boston Red Sox (1946–1947), the Pittsburgh Pirates (1948–1956), and the New York Yankees (1957–1958). Although the Southern League folded in 1900, it was succeeded in 1901 by the Southern Association, which lasted until 1960 and in turn was succeeded by the South Atlantic (SAL or Sally) League, which is still in operation today.

From these early beginnings to the present-day New Orleans Zephyrs of the Pacific Coast League, local fans have continued the tradition of baseball in New Orleans. No single volume could hope to detail the rich and colorful history of baseball in this city. What follows is a collection of memories, images, and anecdotes that I hope will provide the reader with an appreciation for the rich heritage of baseball in the Crescent City.

I would like to acknowledge the following persons who have assisted me over the years in compiling the information and photographs you will see here: my wife, Claire, who has encouraged me and endured me throughout this project, but who remains my biggest fan and my source of inspiration; Arthur O. Schott, Louisiana's official baseball historian and a true gentleman who shared his vast trove of resources willingly and frequently; Wayne Everard of the New Orleans Public Library; James Sefcik and Nathanial Heller of the Louisiana State Museum; Clyde Smoll, Ron Swoboda, and John Mooney of the New Orleans Zephyrs; Rick Dickson and Richie Weaver of Tulane University; Brett Simpson and Art Carpenter of Loyola University; Abby Dennis of the University of New Orleans; John Magill of The Historic New Orleans Collection; Scott Reifert and Ron Vesely of the Chicago White Sox; Bart Swain of the Cleveland Indians; Jim Moorehead of the San Francisco Giants; and Paula Homan of the St. Louis Cardinals.

To Helen Gilbert, Lenny Yochim, Ralph Caballero, Edwin Palmer, Hoyt Powell, Tom Benson, and the countless unnamed others who have donated information, photographs, memories, and inspiration throughout the years, my profound thanks.

FIRST INNING

The Early Years
1860–1899

The birth of baseball began in 1842 and evolved into a national game by the time the Civil War broke out. This was baseball's most colorful era, a time dominated by unique characters and mustachioed men with nicknames like Piano Legs Hickman and Noodles Hahan. The newly formed New Orleans Pelicans (1887) attracted their share of distinctive players with flashy nicknames—Jumbo Cartwright, Bones Ely, Sadie Houck, and Count Campau.

The rules of baseball were different then with pitchers throwing underhanded, the pitcher's mound being only 45 feet from home plate, and batters requesting a pitch to be thrown high or low. If they didn't see an offering they liked, it took nine balls instead of four to draw a base on balls. In the 1880s, players began wearing rudimentary gloves to help them field. Balls caught on one hop were outs.

Games were played with only three balls, many of which resembled black beanbags after nine innings of being rubbed with tobacco and licorice juice, and being pelted all over the ball yard. Obviously, the state of the ball was a detriment to home runs. Factor in the large, open parks and it is understandable that home runs were certainly a premium. Teams were left to rely on the hit and run, singles, bunts, and stolen bases to win games.

Spitballs were legal. Catchers stood six to ten feet behind the hitter, with a single umpire to call the game. The rules underwent gradual changes in 1854, 1889, and 1893. By the turn of the century, baseball had basically evolved into the game we know today. New Orleans has always embraced new and different influences brought to the city by rail or through the port, and so it was with baseball. There are newspaper accounts of games played by teams associated with the Louisiana Base Ball Association as early as July of 1859. They were played on the Delachaise estate, then on the outskirts of the city near present-day Louisiana Avenue.

The spring of 1870 brought the nation's first professional baseball club, the Cincinnati Red Stockings and the Chicago White Stockings, both of whom came to New Orleans to play local amateur clubs. The tropical climate allowed teams to work off the winter weight. But while the Red Stockings continued traveling from town to town, Tom Foley kept his club in New Orleans for the entire spring, giving birth to the concept of spring training.

By the 1880s, the city boasted several baseball parks that hosted amateur and collegiate teams, as well as the professional teams who occasionally barnstormed through the South. In 1887 a group of local businessmen, led by Toby Hart, secured a franchise in the two-year old Southern League, and the New Orleans Pelicans were born. Over the ensuing years, an ambitious young outfielder named Abner Powell introduced several innovative ideas to the game of baseball.

9

1870 Cincinnati Red Stockings. The country's first true professional baseball club came to New Orleans in 1870. When the *Daily Picayune* first announced the tour, there was tremendous demand on the part of the city's local clubs for the opportunity to represent New Orleans. After much debate, a five-game schedule was arranged. Between April 25 and April 30, the Red Stockings overwhelmed their competition: the Pelicans (51-1), the Southerns (79-6), the Atlantics (39-6), the Lone Stars (26-7), and the Robert E. Lees (24-4). Over two seasons the Cincinnati Red Stockings won 126 games while losing only 6 games for an incredible .955 winning percentage. (Collection of the author.)

IT HAPPENS EVERY SPRING. The very first spring training baseball camp was held in New Orleans in 1870. The Chicago White Stockings' manager Tom Foley was looking for an escape from the harsh northern winters. In New Orleans he found a city with a mild tropical climate, a large and enthusiastic fan base, and at least a half-dozen baseball parks to host his players. The White Stockings were led by Adrian "Cap" Anson, depicted here in an early tobacco card. His reputation as a fierce competitor was overshadowed by his refusal to allow his players to play teams that had African-American players. Baseball promoters caved in to the drawing power of Anson and the White Stockings. Black baseball players were banned from major league teams until 1947. (Collection of the author.)

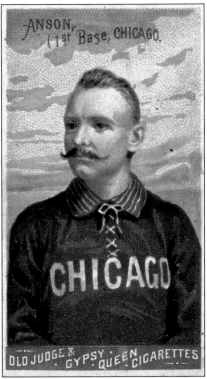

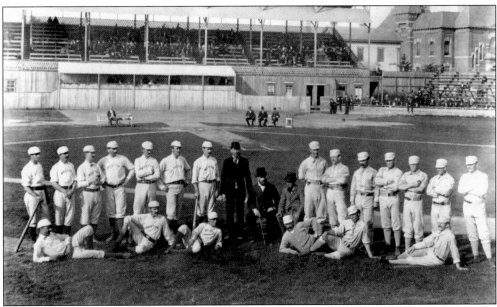

1884 BOSTON BEANEATERS. Led by 29-year old player/manager John Morrill, the Boston Beaneaters got a head start on the 1884 season by holding their spring training camp in New Orleans. Boston would go on to finish 73-38, 10 games behind Providence. Shown here in their home park, the first South End Grounds, the Beaneaters have endured to become the oldest continuously operated franchise in major league baseball history. They are now known as the Atlanta Braves. (Collection of the author.)

ABNER POWELL. Abner Powell was an outfielder, pitcher, and the manager on the 1887 New Orleans Pelican team. One of the most overlooked figures in baseball history, Powell is credited with many innovations: the canvas tarpaulin, establishing Ladies' Day, and the use of a detachable rain check. Instead of being known as an innovator, Powell is best remembered for an incident that occurred on August 22, 1886, in a game with the Louisville Colonels. With the score tied 3-3 in the bottom of the 11th inning, William "Chicken" Wolf laced a line drive toward the right field corner. A stray dog that had been napping in the outfield awakened and joined outfielder Powell in a chase for the ball. When it appeared Powell was winning the race, the dog bit into his leg and refused to let go, allowing Wolf to run out an inside-the-park home run. Powell died in New Orleans on August 8, 1953, at the age on 92. (Courtesy of Hoyt Powell.)

MARK POLHEMUS. Mark Polhemus was born on October 4, 1862, in Brooklyn, New York. He made his major league debut on July 13, 1887 with the Indianapolis Hoosiers (National League). Polhemus also spent two seasons with the New Orleans Pelicans. He was a member of the 1889 pennant winning team, playing 52 games in the outfield and capturing four Southern League titles: runs (63), hits (90), doubles (18), and batting average (.369). In 1893 he played in 55 games, but could not help the Pelicans finish any better than eighth place, despite his .347 batting average, 77 hits, and 17 doubles. Polhemus died on November 12, 1923, in Lynn, Massachusetts, at the age of 61. (Collection of the author.)

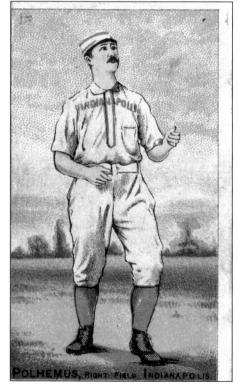

POLHEMUS, RIGHT FIELD INDIANAPOLIS

CHARLES "COUNT" CAMPAU. Charles "Count" Campau enjoyed a sporadic three-year professional career with three different teams. He was the only player ever to lead two leagues in home runs in the same season (1890, International League and American Association). Under Abner Powell, Campau played outfield off and on for the Pelicans (1887–1894). In the Pelicans' first season, Campau led the Southern League in triples with 12 while batting .398, helping them take their first pennant. Returning in 1892, he played only 39 games. After a mediocre season in 1893, Campau led the league in home runs (11) and stolen bases (50) in 1894. His performance was good enough to merit his return to the big leagues with Washington for the remainder of the 1894 season. When Powell departed New Orleans to assume control of the Atlanta Crackers, Campau was one of three managers during the 1903 season, along with second baseman Zeke Wrigley and outfielder Joe Rickert. He died in New Orleans on April 3, 1938, at the age of 74. (Private Collection.)

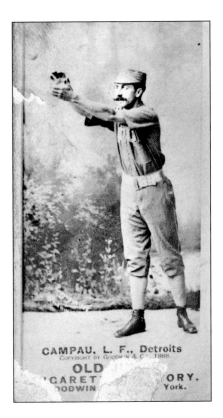

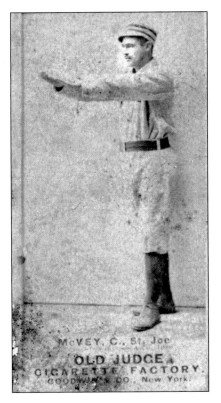

GEORGE McVEY. George McVey's professional career began on September 19, 1885, at the tender age of 19 and consisted of three games at first base and three games at catcher for the Brooklyn Grays. McVey was a member of the 1887 New Orleans Pelicans where he played catcher, first base, and outfield. He even pitched in two games during the season. McVey helped the Pelicans bring home a Southern League pennant in their first season. McVey died on May 3, 1896, in Quincy, Illinois at the age of 30. (Collection of the author.)

13

DETACHABLE RAIN CHECK. In baseball's early days, heavy cardboard tickets were sold and turned in at the end of the game, so they could be used again. Fence jumpers started joining the paying customers in line seeking tickets for a later game after a rainout, and Pelican player-manager Abner Powell noticed that the team was issuing more rain checks than tickets they had sold. He developed the idea of a perforated rain check stub, a practice that is still used on virtually all event tickets today. Powell never patented the idea, but he is widely acknowledged as having come up with it in 1889. (*Collection of the author.*)

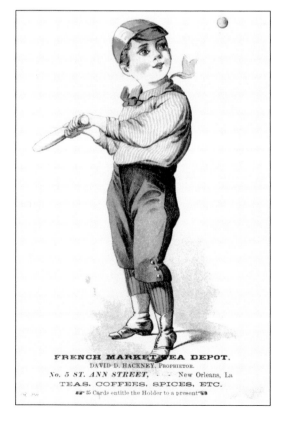

BASEBALL'S A HIT. The growing popularity of baseball in New Orleans is evidenced by this *c.* 1887 tradecard for the French Market Tea Depot. (Courtesy of the Historic New Orleans Collection.)

14

WILLIAM "SHORTY" FULLER. Fuller was a 19-year-old shortstop when he came to New Orleans to play on Abner Powell's inaugural edition of the Pelicans in 1887. The diminutive (5-foot, 6-inch) Fuller played in all 113 games and hit .325 in the Pelicans' first season. When the Southern League folded in 1888, he headed north and began his major league career with the Washington Nationals (National League). In all, Fuller played nine seasons in the major leagues. (Private Collection.)

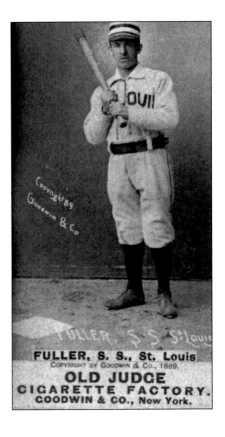

FULLER, S. S., St. Louis
COPYRIGHT BY GOODWIN & CO., 1889.
OLD JUDGE
CIGARETTE FACTORY.
GOODWIN & CO., New York.

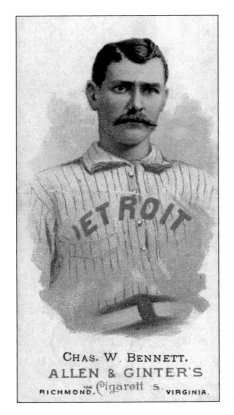

CHAS. W. BENNETT.
ALLEN & GINTER'S
RICHMOND. Cigarett s. VIRGINIA.

CHARLES W. BENNETT. This Detroit native had already played 15 years as a major league catcher and outfielder from 1878 to 1893 when he found his way to New Orleans as a 40-year-old utility player for Abner Powell's 1895 edition of the Pelicans. (Private Collection.)

15

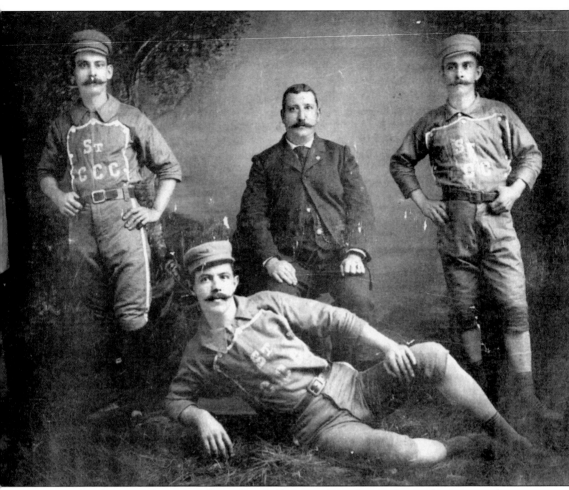

1894 St. Charles Catholic Club. Baseball overtook cricket as the city's most popular sport just before the outbreak of the Civil War. By the 1870s there were dozens of amateur teams organized under the Louisiana Base Ball Association. The games attracted between 1,000 and 2,000 fans, each of whom paid an admission of 25¢. Baseball was a lucrative way to finance the activities of these clubs, including the St. Charles Catholic Club. In 1894, three members of the club's baseball team posed for this photograph. Teammates George Leitz and Joseph Preted flank the club's coach, identified only as Coach Burkhadrt. Reclining in the foreground is Joseph Groetsch. The club was located in the area of the city known as the Irish Channel, at 2043 Constance Street, and was quite likely affiliated with St. Alphonsus Parish. (Courtesy of George Groetsch.)

Second Inning

A New Century

1900–1909

The century began with the formation of several new leagues. Ban Johnson fought to bring the American League on an equal footing with the established National League. He did so with the financial backing of Charles Somers, a Cleveland coal-heir would also played a major role in the development of baseball in New Orleans. Meanwhile, Abner Powell, Charley Frank, and Newt Fischer resurrected the Southern Association from the ashes of the Southern League.

Teams struggled in the early years to make a go of the game. In 1905 the New Orleans Pelicans won their first Southern Association pennant under manager Charley Frank and behind the solid pitching of Jimmy Dygert (18-4), despite having to play their home games in Meridian, Mississippi, during the final weeks of the season due to an outbreak of yellow fever in New Orleans that led to the city being quarantined. The Pels finished fourth in 1906, third in 1907, and second in 1908, and they closed out the decade with another fourth-place showing. During this time, in 1908, Take Me Out To The Ball Game *became a national standard.*

Through the first decade of the 20th century, baseball remained a game of strategy. The so-called "dead ball" provided few home runs. The game relied on contact hitters, bunting, and base-stealing for its offense. The adoption of a ball with cork centers in 1911 changed the game dramatically. Forty years of batting records began to fall and the popularity of the game began to explode.

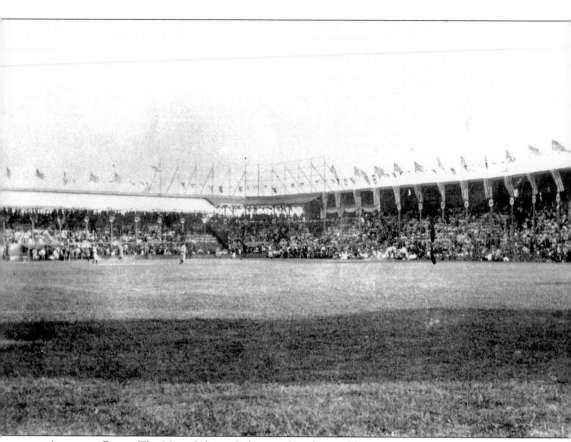

ATHLETIC PARK. The New Orleans Pelicans played at Athletic Park from 1901 through 1907. The stadium, shown here in 1905, was located on Tulane Avenue between South Carrollton Avenue and South Pierce Street in mid-city. In 1908, the Pelicans moved approximately five city blocks away to Pelican Park, located on South Carrollton Avenue between Banks Street and Palmyra, across the street from the present-day Jesuit High School. (Courtesy of the Historic New Orleans Collection.)

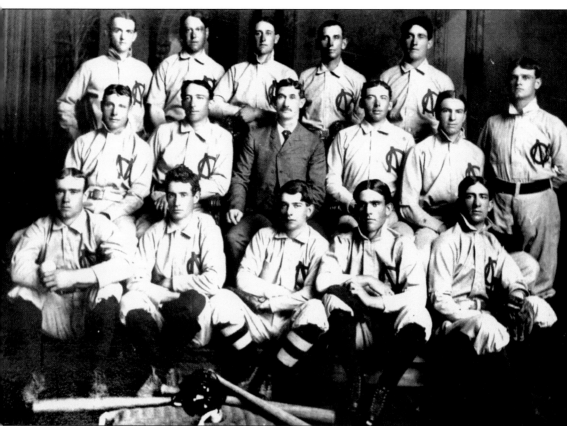

1902 NEW ORLEANS PELICANS. The 1902 New Orleans Pelicans began their second year in the newly formed Southern Association under player/manager Abner Powell (middle row, third from left). They ended the season in third place with a record of 72-47 (.605 winning percentage). This was the last year Powell served as the team's manager. The team included, from left to right, (front row) Ed High, James Smith, Harry Deisel, John Mullen, and Jake Atz; (middle row) George Bradford, John Herbert, Abner Powell, Robert Stafford, Lute Freeland, and Jesse Danhover; (back row) Joseph Stanley, Frank Norcum, Larry Tewart, Robert Westlake, and Fred Abbott. Jake Atz was with the Pelicans as a middle infielder and was soon on his way to the Chicago White Sox. These fellows had to be of hearty stock as many of them were playing in North Carolina when Abner Powell purchased their team for $1,200 in early 1901. He then fired his entire team and replaced them with a crew from North Carolina. (Courtesy of Arthur O. Schott.)

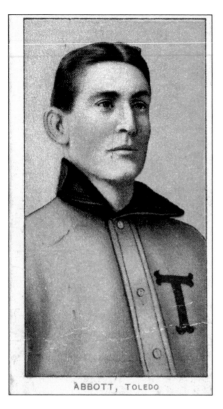

ABBOTT, TOLEDO

FRED ABBOTT. Born Fred Winbilger on October 22, 1874, in Versailles, Ohio, he had changed his name to Fred Abbott by the time he reported to Abner Powell's 1898 New Orleans Pelicans. He played 15 games in the outfield and third base, batting .265 for the season. Abbott returned to the Pelicans when they entered the newly formed Southern Association in 1901, this time alternating between third base and catcher. Abbott played 105 games at catcher, first base, shortstop, and second base, while batting .279 for the 1902 season. He was sent up to the Cleveland Indians for the 1903 season and made his debut on April 25, 1903, at the age of 28. In all he spent three years in the major leagues. This image shows Abbott when he was with the Toledo Mud Hens in 1911. He died on June 11, 1935, at the age of 60 in Los Angeles. (Collection of the author.)

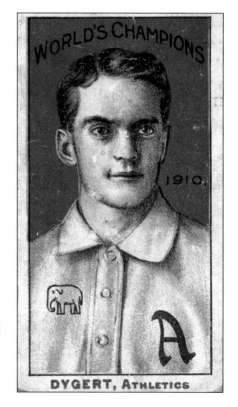

DYGERT, ATHLETICS

JAMES "SUNNY JIM" DYGERT. Born in Utica, New York, on July 5, 1884, Dygert was an infamous spitballer with the Philadelphia Athletics from 1905 through 1910, compiling a 57-49 record. He came to the New Orleans Pelicans in 1905, putting up a record of 18-4 in 23 starts that earned him a trip to Connie Mack's Philadelphia A's at the end of the season. He returned to the Pelicans for the 1913 season. During an exhibition game on March 29, 1913, in old Pelican Park, Dygert pitched a complete game, one-hit shutout against the vaunted Cleveland Naps, which featured such stars as Nap Lajoie and Shoeless Joe Jackson. He died of pneumonia in New Orleans on February 8, 1936, at the age of 52. (Collection of the author.)

JAKE ATZ. Born John Jacob Zimmerman in Washington, D.C., on July 1, 1879, Jake learned the plumber's trade and in his early 20s did fairly well as a vaudeville comedian. However, his true love was baseball. He was with a small club in North Carolina around the turn of the century when the club encountered financial difficulties. The players were paid off with what remained in the treasury, lining up in alphabetical order. By the time they arrived at Zimmerman, the coffers were empty. Jake decided he would never be in that position again. When he signed his next contract he was John Jacob Atz, making sure he would be at the head of the next payroll line, not the rear. He subsequently had the name change legally. (Collection of the author.)

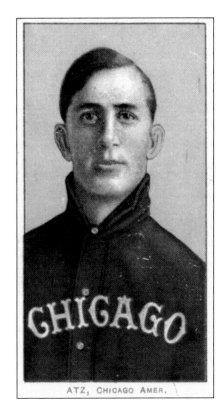

ATZ, CHICAGO AMER.

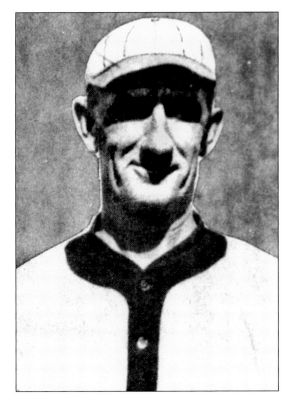

JAKE ATZ. He reached the majors for the first time in 1902 with his hometown Washington team, going 1-for-10 in three games. Atz played for the New Orleans Pelicans from 1902 until 1906 and was with six other minor league clubs in the next five years. He returned to the majors when the Chicago White Sox purchased him from New Orleans late in 1907. Atz was with the White Sox through 1909, batting .209 in 218 games. He returned to the New Orleans Pelicans in 1913 as a player and in 1932 as a manager. He died at the age of 65 in New Orleans on May 22, 1945. (Courtesy of Arthur O. Schott.)

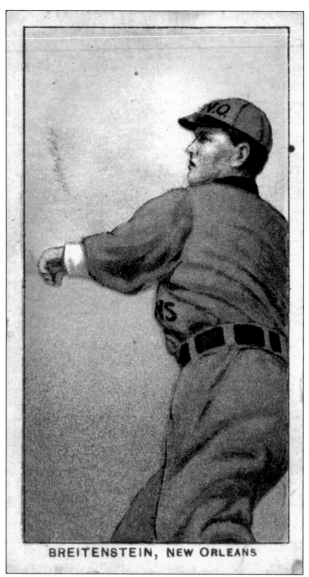

BREITENSTEIN, NEW ORLEANS

THEODORE "TED" BREITENSTEIN. Theodore P. "Ted" Breitenstein was a left-handed fireballer who pitched for the New Orleans Pelicans from 1904 through 1911. He began his professional career at age 22 with his hometown St. Louis Browns on the final day of the season against Louisville on October 4, 1891, by hurling a no-hitter for manger Charles Comiskey. His teammates were afraid of putting the jinx on him, so no one said a word to him during the game. It was nearly the third perfect game in baseball history save for a single base on balls issued. He was not even aware of his accomplishment until after the game. He came south to play for manager Charley Frank for the Memphis Egyptians in the newly formed Southern Association and spent the next 10 years mowing down batters across the Dixie circuit. After two seasons with Memphis (1902–1903) he followed manager Frank to New Orleans for the 1904 campaign and spent the next eight years as a Pelican (1904–1911). As a member of three pennant-winning Pelican teams (1905, 1910, and 1911), Breitenstein compiled a record of 122 wins with 64 losses in 226 appearances. He died in St. Louis on May 3, 1935, at the age of 65. (Collection of the author.)

OTTO WILLIAMS. Starting the 1902 season with the Memphis Frankfurters (Southern Association), Williams was hitting .268 when he was called up to the St. Louis Cardinals, making his debut on October 5, 1902. He spent the 1905 season with the New Orleans Pelicans where he batted .278 despite having to finish the last month of the season on the road due to an outbreak of yellow fever in New Orleans. The Pelicans still brought home the Southern Association pennant. Williams died on March 19, 1937, in Omaha, Nebraska, at the age of 59 from pneumonia. (Private Collection.)

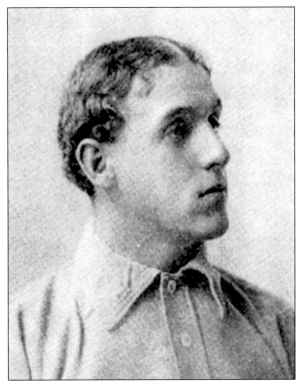

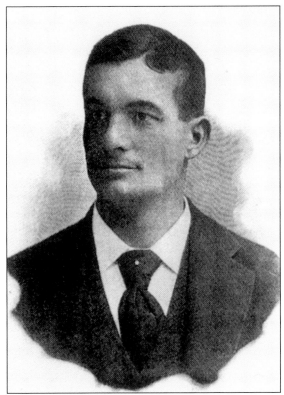

LAFAYETTE "LAVE" CROSS. Born on May 12, 1866, in Milwaukee, Wisconsin, Lafayette Napoleon Cross broke in with the Louisville Colonels (American Association) on April 23, 1887, as a 21-year-old backup catcher alongside of his older brother Amos. He moved to the infield in 1891 but continued to field using his catcher's mitt until the rules were changed. Cross set a record for assists by a second baseman on August 5, 1897, with 15 during a 12-inning game. The mark still stands today. Cross came to New Orleans in 1907 after a brief stay with the Washington Senators and played 86 games for the Pelicans at third base, batting .267 for the season. He returned in 1908 but could only manage 15 games behind Pelican standout George Rohe. He retired at the age of 42 after the 1908 season. Cross worked as a machinist in Toledo, Ohio, where he died on September 6, 1927, from a heart attack at the age of 66. (Private Collection.)

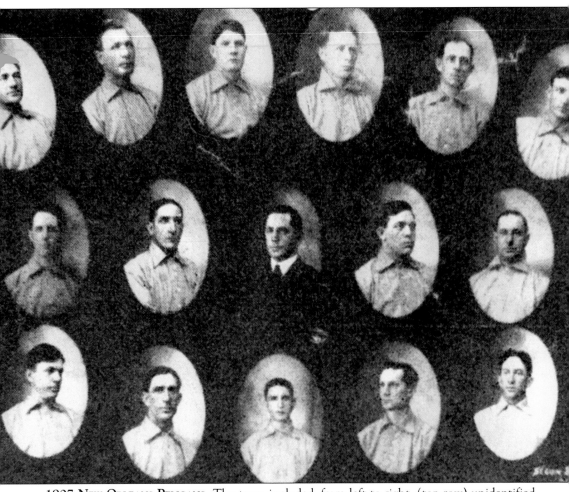

1907 NEW ORLEANS PELICANS. The team included, from left to right, (top row) unidentified, Ted Guese, Ted Breitenstein, William Phillips, William Cristall, and Mark Manuel; (middle row) William Gaston, Joe Rickert, A.J. Heinemann, Harry Matthews, and Philip Nadeau; (bottom row) Milo Stratton, Jake Atz, Ed Sabrie, Frank Gatins, and Robert Tarleton. A.J. Heinemann had started as a soft-drink vendor and would eventually become president and owner of the club. Mark "Moxie" Manuel was a 20-game winner for the Pelicans in 1907, two of which came on the same day. On June 15, 1907, he hurled both ends of a doubleheader against the Birmingham Barons, winning both games by the score of 1-0, allowing only two hits in the first game and six in the second. This earned him another nickname—Ironman. (Courtesy of Arthur O. Schott.)

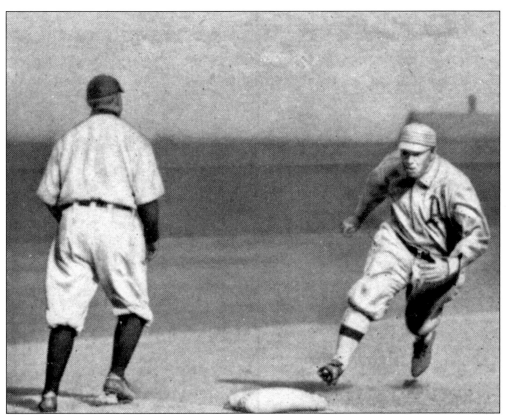

Bris Lord. Born Bristol Robotham Lord in Upland, Pennsylvania, on September 21, 1883, Bris Lord was signed by Connie Mack in 1905 when their regular center fielder was injured. Lord played 119 games in the outfield for the New Orleans Pelicans during the 1908 campaign, batting .314 with 145 hits and 27 stolen bases. His six home runs led the Southern Association. He was reacquired by the A's on July 25, 1910, in one of the most lopsided trades in the history of baseball when Connie Mack sent Shoeless Joe Jackson to the Cleveland Indians for Bris Lord. The man also known as the Human Eyeball died on November 13, 1964, in Annapolis, Maryland at the age of 81. (Collection of the author.)

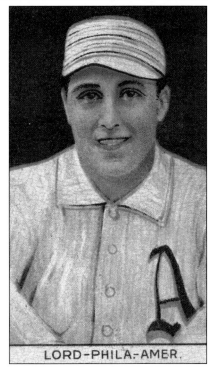

LORD-PHILA-AMER.

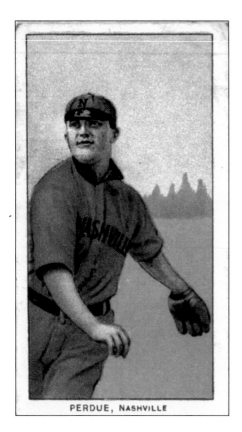

PERDUE, NASHVILLE

HUB "THE GALLATIN SQUASH" PERDUE. After four seasons with the Nashville Volunteers in the Southern Association (1907–1910), Hub Perdue made his debut with the Boston Braves on April 19, 1911. He was traded to the St. Louis Cardinals in 1914 after a 2-5 start and missed the "miracle finish" that saw the Braves climb from the National League cellar to win the World Series. He returned to the Southern Association in 1917 with Nashville. Perdue spent nearly three seasons (1918–1920) in New Orleans with the Pelicans where he put together a record of 34-37 before being traded to Nashville. He retired after the 1921 season. (Collection of the author.)

DAVE DANFORTH. Pitching in almost constant pain, the big Texas lefthander earned the nickname "Dauntless Dave" for his tenacity. He made his major league debut on August 1, 1911, with the Philadelphia Athletics. In all, Danforth spent 10 years in the American League, with the Athletics (1911–1912), the Chicago White Sox (1916–1919), and the St. Louis Browns (1922–1925). He left the Chicago bullpen just in time to avoid being involved in the 1919 World Series scandal with the White Sox. Danforth came to the New Orleans Pelicans for the 1927 season, finishing with a 16-4 record with a 2.25 ERA, and was one of the key players in the club's first place finish. He slipped to 10-11 in 1928 and 8-7 in 1929. After sitting out the 1930 season to rest his arm, he attempted a comeback in 1931 with the Chattanooga Lookouts (Southern Association), but a 4-6 record with a 4.13 ERA led to his retirement. He died on September 19, 1970, in Baltimore, Maryland, at the age of 80.

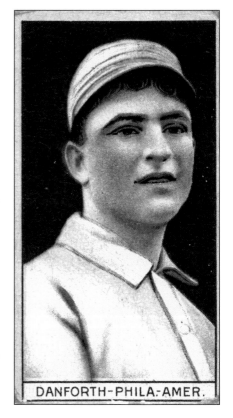

DANFORTH-PHILA.-AMER.

THIRD INNING

Ragtime Baseball
1910–1919

In 1910, New York columnist Franklin Pierce Adams introduced the nation to the exploits of the Chicago Cubs' famous double-play team of "Tinker to Evers to Chance." New Orleanians came alive watching a young man from South Carolina crank out hit after hit. Shoeless Joe Jackson helped lead the New Orleans Pelicans to their second Southern Association title in 1910. The team took over first place in June and coasted to an eight-game lead over the Birmingham Barons. The year 1911 was another banner year for the home team, with the Pelicans capturing their third Southern Association pennant behind the arm of Otto Hess (23-8). A third-place showing in 1912 and a disastrous eighth-place finish in 1913 led to the replacement of manager Charley Frank.

Despite their success on the playing field, the Pelicans were nearly bankrupt. In 1914, A.J. Heinemann was appointed club president and general manager, and he initiated two changes that would turn around the beleaguered Pelican franchise. The first was to construct a new stadium just a mile from their present facility. Using a team of mules to move the wooden grandstand up the street, Heinemann Park was completed at a cost of $50,000 for the 1914 season. It would become a landmark until it was torn down in 1957. Heinemann's second decision was to hire Johnny Dobbs as the team's manager. During the next nine seasons his teams would never finish worse than third place. Dobbs's gruff style of field management was successful and the Pelicans regained their financial and professional stability during the period.

Pitching was still the mainstay of the game. Batters began using lighter bats and stronger swings to hit the ball further. Roy Walker emerged as the Pelican's main strikeout artist, racking up three Southern Association strikeout titles in four years. He also captured the first ever Southern Association title for a new pitching statistic introduced in 1917—the Earned Run Average (ERA).

Baseball survived such diverse threats as the upstart Federal League (1913–1915), which convinced one-third of the players in the American and National Leagues to jump ship for higher wages; the outbreak of World War I (1914–1918); and the global flu epidemic (1918–1920) that claimed the lives of 22 million Americans.

But it was be the outcome of the 1919 World Series that posed the greatest threat of all to baseball. Once again, Shoeless Joe Jackson was at the center of attention.

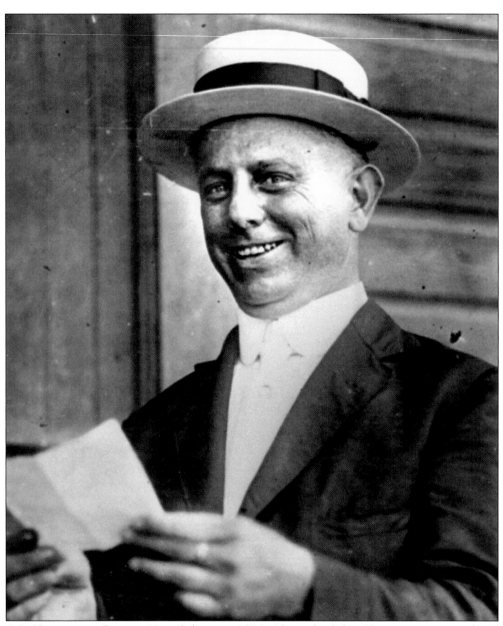

A.J. HEINEMANN. Born in New Orleans in 1876, Alexander Julius Heinemann never played baseball, but he made it his life. He started out as a soft drink vendor in Sportsman's Park and worked his way up through the organization, becoming an officer of the club in 1904 and vice-president in 1912. With the departure of Charley Frank after the 1913 season, Heinemann was appointed president and general manager of the club for the 1914 season. Heine, as he was sometimes affectionately known, is shown wearing his trademark straw hat. He was often seen wandering through the stands in this battered old hat. At the time of his death he still had six brand-new boaters unopened in his office. Severe losses in the stock market crash of 1929 eventually drove Heinemann to take his own life in January of 1930. His handwritten will stipulated that Larry Gilbert was to be repaid for stock losses he suffered after following Heinemann's advice. (Courtesy of Arthur O. Schott.)

JOHNNY DOBBS. Born on June 3, 1876, in Chattanooga, Tennessee, Johnny Dobbs made his major league debut at the age of 26 with the Cincinnati Reds on April 20, 1901. In all he played five seasons in the majors from 1901 to 1905. Dobbs made his mark on baseball as a minor league manager. He came to New Orleans for the 1914 campaign after stints with Nashville, Chattanooga, and Montgomery. During the next nine seasons Dobbs' teams never finished worse than third place. They captured two Southern Association crowns (1915 and 1918). Dobbs left after the 1922 campaign with a career record of 735 wins and 508 losses in New Orleans. He died on September 9, 1934, at the age of 59 in Charlotte, North Carolina, where he was president of the Charlotte Hornets franchise. (Courtesy of Arthur O. Schott.)

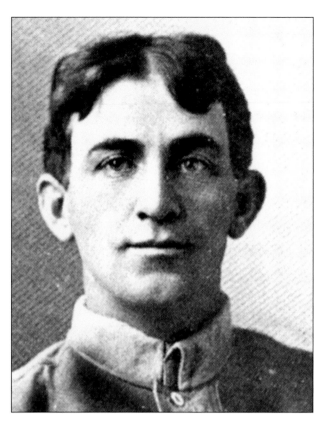

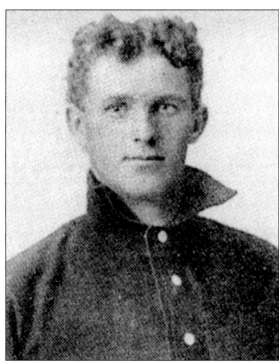

OTTO HESS. Born in Bern, Switzerland, on October 10, 1878, Otto Hess learned the game of baseball while serving with the army in the Philippines. He made his major league debut on August 3, 1902, with the Cleveland Indians. He came to the New Orleans Pelicans in 1909 and was the star of a rotation that included Ted Breitenstein, Charles Pruitt, and George Paige. Hess hurled an 18-12 record in 38 appearances. Often unhittable, and at times uncontrollable, Hess once again led the Pelicans pitching staff in 1910 (25-9) on their way to winning their second Southern Association pennant. In his third and final season in New Orleans in 1911, Hess was 23-8 and the Pelicans took the pennant. Tuberculosis caught up with Hess on February 25, 1926. He died in Tuscon, Arizona, at the age of 47. (Collection of the author.)

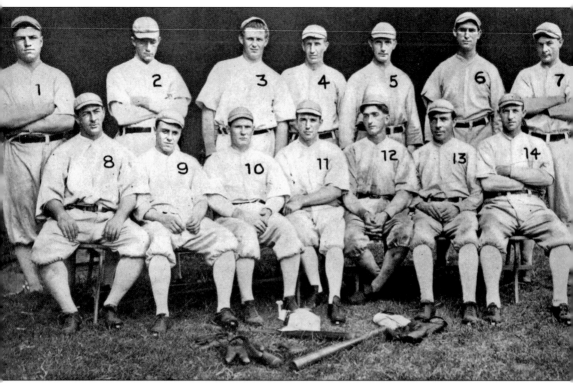

1910 NEW ORLEANS PELICANS. The 1910 New Orleans Pelicans, under manager Charley Frank, won their second Southern Association crown. The team took over first place in June and never looked back, finishing 87-53 (.621), eight games ahead of Birmingham. The team consisted of, from left to right, the following: (front row) John Weimer, Hyder Barr, Ted Breitenstein, Gordon Hickman, William Lindsay, Joe Jackson, and Frank Manush; (back row) Henry Butcher, James Lafitte, Bert Maxwell, George Paige, John Mitchell, and O.J. Dugey. Joe Jackson was the standout, leading the Southern Association in batting average (.354) with 165 hits and 82 runs. (Collection of the author.)

JOE JACKSON. The 1910 edition of the New Orleans Pelicans boasted one of the most legendary and colorful players ever to don baggy flannels—a young man from Pickens County, South Carolina, named Joseph Jefferson Jackson, or Shoeless Joe Jackson. He played 136 games for the 1910 club, batted .354, and led the Pelicans to their second Southern Association pennant. Jackson was almost painfully shy, due in part to being illiterate. He was also very superstitious and had to be coaxed into having his picture taken with the 1910 Pelicans. (Courtesy of the Chicago White Sox.)

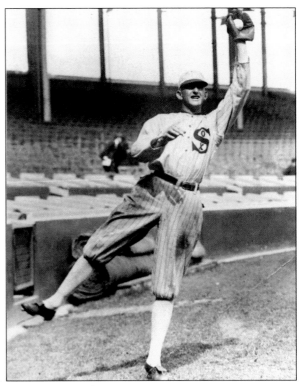

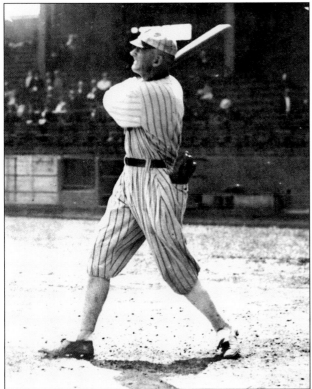

SAY IT AIN'T SO. Shoeless Joe went on to play for the Cleveland Indians and the Chicago White Sox. He became infamous as a member of the 1919 Chicago Black Sox, accused of throwing the World Series against a Cincinnati team considered to be far inferior. He and seven of his teammates were banned from baseball for life by newly appointed commissioner Judge Kennesaw Mountain Landis. Whether or not you believe he was involved in the scandal—and his performance during the Series indicates he was not—baseball lost one of its greatest players. He died on December 5, 1951, in Greenville, South Carolina, at the age of 62 from a coronary thrombosis caused by cirrhosis of the liver. (Courtesy of the Chicago White Sox.)

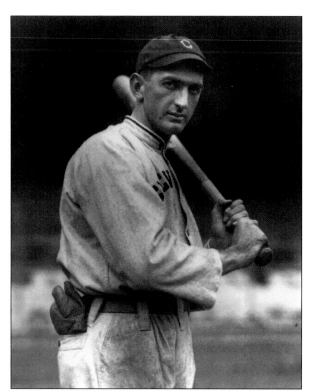

PROPERTY OF THE INDIANS.
Jackson returned to New Orleans in March of 1911 to train with the Pelicans before reporting to Cleveland's spring training camp in Alexandria, Louisiana. He felt more at ease among familiar faces in New Orleans, and this helped him overcome the taunts of opposing players during the 1911 season. Jackson was also quite fond of vaudeville shows and took advantage of the many venues offered in New Orleans at the time. He later supplemented his off-season income by touring with his own vaudeville review. (Courtesy of the Cleveland Indians.)

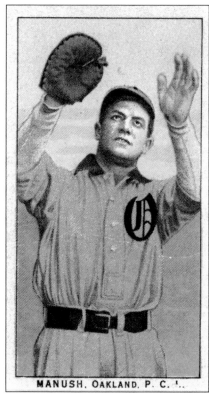

MANUSH. OAKLAND. P. C. L.

FRANK MANUSH. Frank Manush played third base in New Orleans as a member of back-to-back pennant-winning 1910 and 1911 Pelican teams, batting .256 and .263 respectively. Manush was traded to Atlanta during the 1912 season. His younger brother, Heine, also played baseball and was elected to the Professional Baseball Hall of Fame. He died in Laguna Beach, California, on January 5, 1965 at the age of 82. (Private Collection.)

GEORGE "PIGGY" PAIGE. George (Pat) Paige pitched for six seasons in the Southern Association (1909–1914). The lefthander got his start in New Orleans as a member of the 1909 Pelicans. His breakout season came in 1910 when he had 24 wins and 14 losses, leading the Pelicans to a Southern Association pennant. It would be his only 20 win season. Paige died on June 8, 1939, in Berlin, Wisconsin, at the age of 57. *(Private Collection.)*

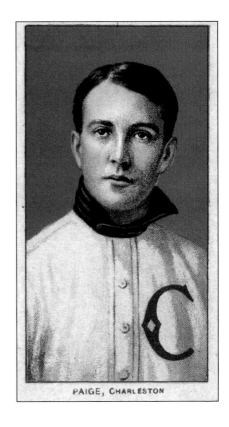

PAIGE, CHARLESTON

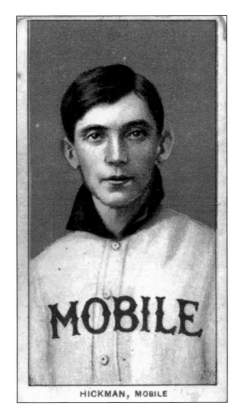

HICKMAN, MOBILE

GORDON HICKMAN. Gordon Hickman was a journeyman pitcher in the Southern Association. Between 1906 and 1910 he played for five teams, compiling a record of 61 wins and 67 losses. He came to the New Orleans Pelicans in mid-season in 1910 from Mobile but was traded to Montgomery before the end of the season and was not part of the Pelicans pennant winning club. (Collection of the author.)

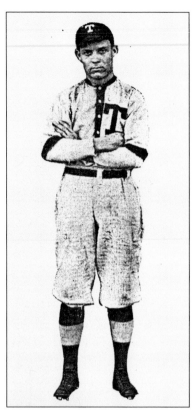

TULANE CATCHER. A serious young man, Maurice J. Picheloup played catcher and first base for the Tulane Green Wave under head coach Bruce Hays in 1911 and 1912. The 1911 squad went 3-3, with the three wins coming against LSU. The 1912 team did not fare as well, going 3-6-1, losing three out of four to LSU. After graduation he went into the construction business for a short time and was serving in the navy in Algiers when he died at the age of 25 in the flu epidemic that hit New Orleans in 1918. (Courtesy of Maurice J. Picheloup III.)

USS NEBRAKSA. The USS *Nebraska* was launched in 1904 and commissioned in 1907 as a Virginia-class battleship in the Atlantic fleet. The ship visited New Orleans in April of 1912 to take place in the festivities surrounding the Louisiana Centennial celebrating the 100th anniversary of Louisiana's statehood. Among the *Nebraska*'s 1,108-man complement were 15 sailors who made up the ship's baseball team. During their visit, the Nebraska's team faced off against Tulane at Athletic Park, besting the Green Wave 3-2. The USS *Nebraska* was decommissioned on July 20, 1920. (Collection of the author.)

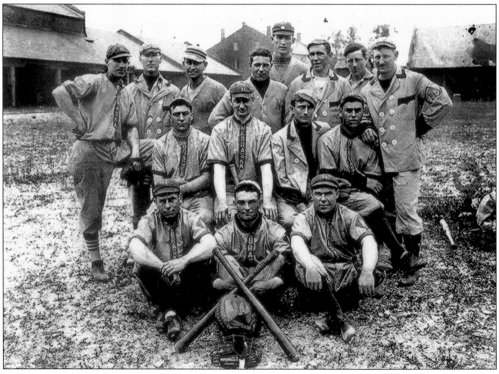

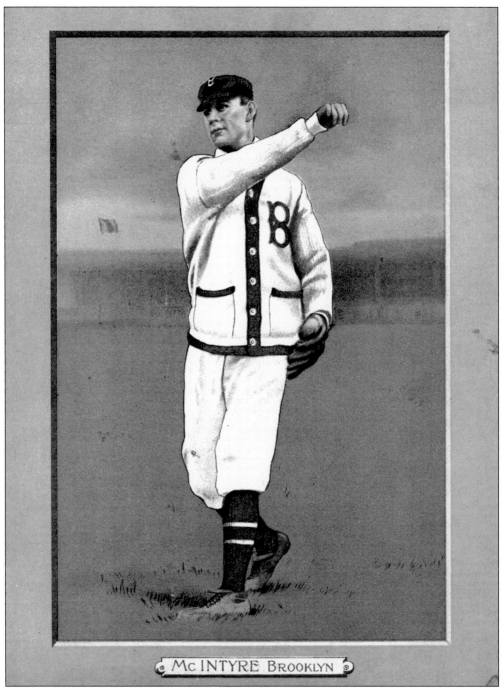

McINTYRE BROOKLYN

HARRY McINTYRE. McIntyre spent three seasons pitching with three different teams (1902–1904) before earning his first start in the majors with the Brooklyn Superbas on April 14, 1905. He labored for five seasons with the mediocre forerunner to the Dodgers before being traded to the Chicago Cubs in 1910. He came to the New Orleans Pelicans at the end of his career, and in two seasons (1913–1914) he was 5-6. He retired after the 1914 season. McIntyre died on January 9, 1949, in Daytona Beach, Florida, at the age of 69. (Private Collection.)

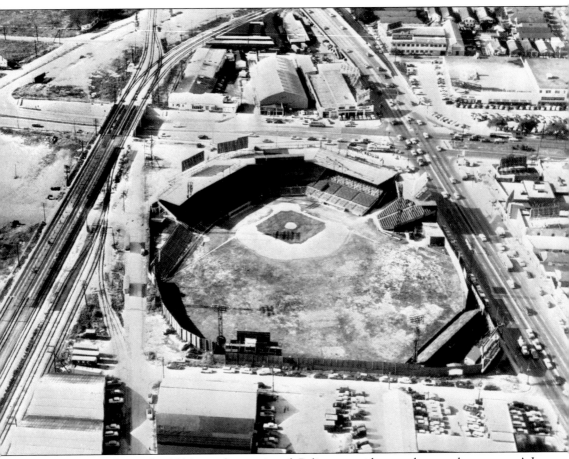

HEINEMANN PARK. In 1914, newly appointed Pelican president and general manager A.J. Heinemann used mule teams to move the wooden bleachers from the old Sportsman's Park to an open tract of land up the street that had once housed the White City Amusement Park. There he constructed a new ball yard of cavernous dimensions—427 feet down the left field line, 405 feet to dead center, and 418 feet down right field—at a cost of $50,000. The Pelicans played the 1915 season in their new home, named Heinemann Park, bringing home their fourth Southern Association pennant under second-year manager Johnny Dobbs. It was renamed Pelican Stadium in 1938. The facility was located at the corner of Tulane Avenue and South Carrollton Avenue, next to the rail line, making the commute from the city easier for the working man. (Courtesy of Arthur O. Schott.)

FOURTH INNING

The Glory Years
1920–1939

New rules, a new ball, and new heroes—baseball had them all in 1920. How could the sport survive with the country focused on the Black Sox scandal? Baseball's first move was to hire Judge Kennesaw Mountain Landis as the first commissioner. Landis had brokered the deal that brought an end to the Federal League and was remembered kindly by the owners. He was granted unprecedented authority and power by them, and he quickly banned eight players from the Chicago White Sox from professional baseball for life.

Yet baseball needed something else, something to divert the public's attention away from the Black Sox scandal. What it received was a new hero, a figure of epic proportions—a man by the name of George Herman "Babe" Ruth. In 1920, Boston Red Sox owner Harry Frazee sold Ruth's contract to the New York Yankees for $125,000. Ruth became an immediate national hero.

No longer was a single ball used throughout the game. New balls were introduced to increase offensive production. Batters became more aggressive and fans flocked to the ballpark to see a new generation of sluggers hit home runs. It wasn't until 1926 that pitchers gained a foothold with the introduction of the resin bag during games.

New developments in technology—the telephone and the radio—brought baseball a larger nationwide audience in real-time. In New Orleans, WSMB broadcast Pelican games from their studios in the Maison Blanche building, receiving details of the game via telephone from Heinemann Park. Fans would be regaled with the exploits of Roy Walker, Ike Boone, Joe Martina, and Harvey Hendrick. In 1917, Heinemann purchased the contract of Larry Gilbert, the first New Orleanian to play in a World Series game. It was the beginning of one of the most successful baseball partnerships in the history of the game.

In 1920, the management of the Southern Association and the Texas League arranged for the pennant winner from each league to face off in a best-of-seven series labeled the Dixie Series. The idea was an immediate success. Tragedy stuck millions of Americans with the stock market crash in 1929. A.J. Heinemann sustained heavy losses, and in 1930 he committed suicide. Cleveland Indians' owner Charles Somers purchased the Pelicans from Heinemann's estate. After years of serving as the unofficial farm team for several major league clubs, the Pelicans became affiliated with the Cleveland Indians in 1933. By the end of the era, clouds were gathering on a more serious front and many players would soon be called up to serve for a different team—the United States military.

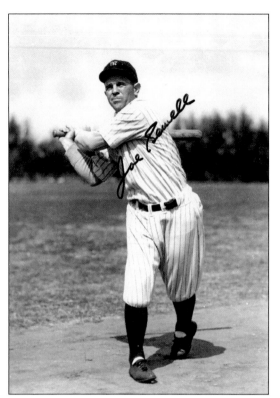

JOE SEWELL. Without question the toughest batter in baseball history to strike out, Joe Sewell was a consistent .300 hitter during his 14 seasons with the Cleveland Indians and the New York Yankees. Yet it was a tragic accident that brought Sewell to the majors from New Orleans. On August 16, 1920, Cleveland second baseman Ray Chapman was hit in the temple by a pitch thrown by Yankee Carl Mays and died 12 hours later. When Chapman's replacement, Harry Lunte, was hurt on Labor Day, Cleveland summoned Sewell from the New Orleans Pelicans to play shortstop. Far from being overwhelmed by the assignment (Sewell was batting .289 in 92 games with New Orleans), the rookie made his debut on September 10, 1920, and batted .329 down the stretch to lead the Indians to their first pennant. He was elected to the Hall of Fame in 1977 by the Veterans Committee. Sewell died at the age of 91 on March 6, 1990, in Mobile, Alabama. (Collection of the author.)

ARTHUR CLARENCE "DAZZY" VANCE. Born on March 4, 1891, in Orient, Iowa, Vance waited a long time for his break. After a decade in the minors, he was well on his way to burning out his arm. Despite great starts, his arm tired by mid-season. Pelican manager Johnny Dobbs allowed Vance to start on four days rest instead of the usual three days. He responded by hurling a 21-11 record in 1921 and was bought by the Brooklyn Dodgers. Actually, it was Dobbs who convinced the Dodgers to take Vance. Dodger scout Larry Sutton was originally interested in Vance's battery mate, catcher Hank DeBerry. Vance died at the age of 69 on February 16, 1961, in Hermosa Springs, Florida. (Courtesy of Bettman/Corbis.)

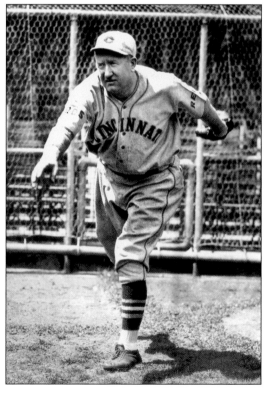

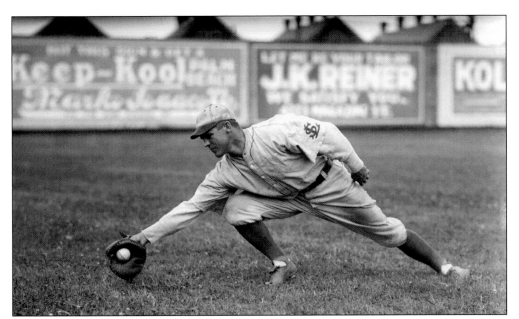

SPRING TRAINING 1921. The St. Louis Browns held their spring training camp in New Orleans in 1921. Here their star first baseman George Sisler is shown reaching for a ground ball on March 31, 1921. Sisler and the Browns would go on to an 81-73 season, ending up third in the American League. Sisler finished the 1921 season batting .371 with 12 home runs and 104 RBIs. (Courtesy Bettman/Corbis.)

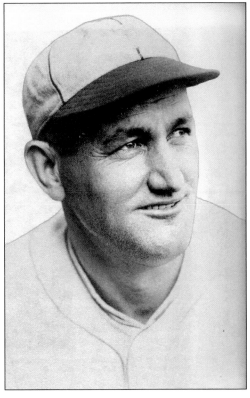

IKE BOONE. A product of the University of Alabama, outfielder Boone hit well in several trials in the majors, but his lack of speed handicapped him in the field and on the bases. Over a sporadic 10-year span in the majors from 1922 through 1932 he played in 356 games, batting .319 with 26 home runs and 192 RBIs. Boone spent just a single season with the New Orleans Pelicans in 1921, when he led the Southern Association in batting (.389), doubles (46), triples (27), and RBIs (126). He died of a heart attack in Tuscaloosa, Alabama, at the age of 61. (Courtesy of Arthur O. Schott.)

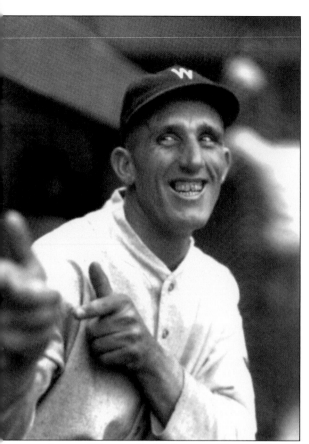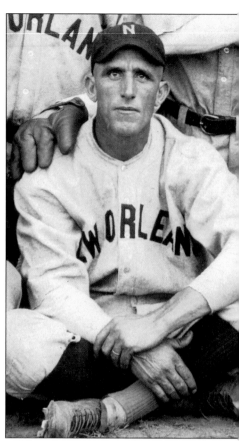

JOSEPH "OYSTER JOE" MARTINA. Born in New Orleans on July 8, 1889, Joe Martina was a right-handed flamethrower who spent seven years with Beaumont (Texas League) and another seven with the hometown New Orleans Pelicans, on his way to a minor-league record of 349-277 with 2,770 strikeouts. In his first season with the Pelicans, Martina made 15 appearances during the 1916 season and finished with a 6-1 record and 36 strikeouts. He was back with New Orleans for the 1921 season, posting a 13-16 record in 41 appearances and 105 strikeouts. The year 1922 was his breakout year, authoring a 22-6 record while fanning 115 opposing batters. He repeated his success during the following season by going 21-10 with a league leading 149 strikeouts, as Martina and the Pelicans captured the 1923 Southern Association crown. All of his hard work paid off, and Oyster Joe was signed by the Washington Senators for the 1924 season. He made his debut on April 19, 1924, at the age of 34, on a pitching staff that included future Hall of Famer Walter Johnson. While the Senators would capture the 1924 World Series over the New York Giants in seven games, Martina's 6-8 record was not enough to earn him a permanent spot on the roster. Martina returned to New Orleans for the next four seasons (1925–1928) where he totaled 77 more wins and 46 losses and another 396 strikeouts. He retired after the 1928 season. He died in New Orleans on March 22, 1962, at the age of 72. (Courtesy of Arthur O. Schott.)

SPRING TRAINING 1923. This photo shows a young 20-year old rookie by the name of Ludwig Heinrich (Lou) Gehrig during his first spring training in New Orleans in 1923. He only appeared in 13 games in his initial campaign with the Yankees, going 11 for 26 (.423) with one home run and nine RBIs. The Yankees held their spring training camps in New Orleans from 1922 through 1924, staying at the Hotel Grunwald (later renamed the Roosevelt Hotel), now known as the Fairmont Hotel on Baronne Street in downtown New Orleans. (Courtesy of Bettman/Corbis.)

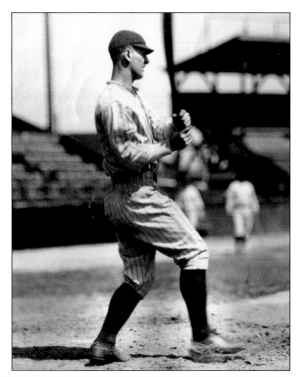

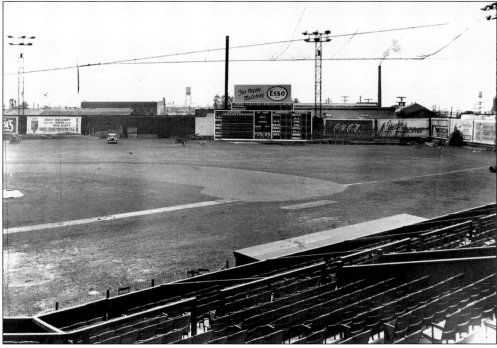

HERE WE GROW AGAIN. When Heinemann Park was first built in 1914, there was a rudimentary outfield fence and no bleachers. With the financial turnaround of the club, bleachers and a scoreboard were added in 1923 to make the facility one of the premier ball yards in the Southern Association. (Courtesy of the New Orleans Public Library.)

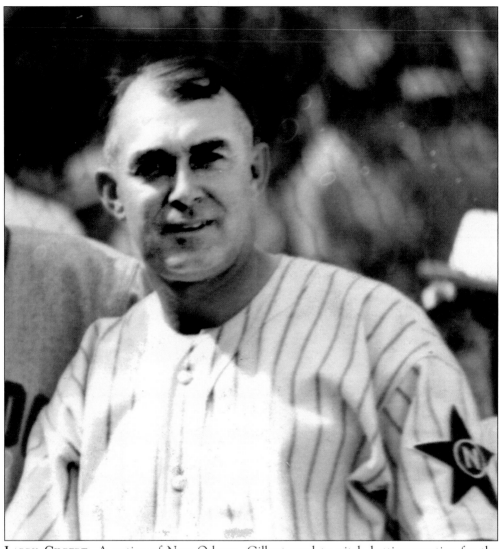

LARRY GILBERT. A native of New Orleans, Gilbert used to pitch batting practice for the Pelicans as a young man and was eventually signed as a pitcher by San Antonio of the Texas League in 1910. He made his professional debut with the Boston Braves on April 14, 1914, as a 19-year-old center fielder and was a member of the miracle Braves that defeated Connie Macks' Philadelphia Athletics in four straight games in the 1914 World Series. He was the first New Orleanian to play in the Series. When A.J. Heinemann bought Gilbert's contract from Kansas City for $2,500 in 1917, he established a new record for a minor league player. Gilbert had his best year as a player in 1919 when he led the Southern Association in hits (171), total bases (237), and stolen bases (42), while posting a .349 batting average. Gilbert's real success, however, came as the field manager of the Pelicans from 1923 through 1938. During his 15-year tenure at the helm, his clubs won five Southern Association championships (1923, 1926, 1927, 1933, and 1934) and two Dixie Series titles (1933 and 1934). He surprised everyone by moving to Nashville in 1939 as owner-manger of the Nashville Volunteers, winning another four Southern Association flags and three more Dixie Series crowns. He retired in 1949 as the most successful manager in the history of the Southern Association. He died in New Orleans on February 17, 1965, at the age of 74.

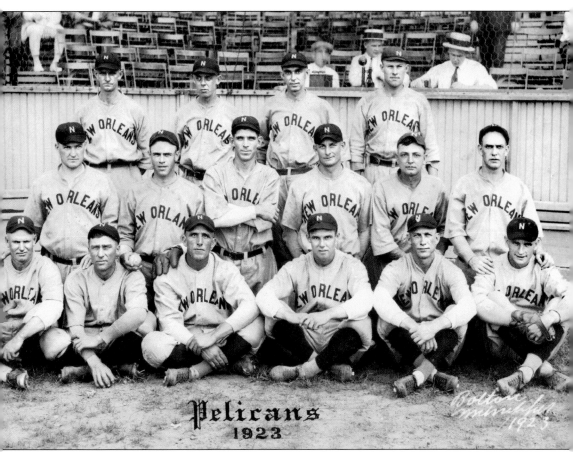

1923 NEW ORLEANS PELICANS. The 1923 edition of the New Orleans Pelicans featured two 20-game winners: Joseph "Oyster Joe" Martina and Roy "Dixie" Walker. Between them they posted a record of 42 wins and 19 losses with 264 strikeouts. The club's total of 498 strikeouts were the most of any team in the Southern Association that year. Under first year player/ manager Larry Gilbert (back row, third from the left) the Pelicans captured the team's sixth Southern Association pennant, finishing five games ahead of Mobile. On the season the Pels went 89-57 (.610) and as a team hit for a .265 average. Players are, from left to right, (front row) William Wittaker (P), Carl Mitze (C), Joe Martina (P), Morrie Schick (OF), Cotton Knaupp (2B), and George Foss (3B); (middle row) Carl Thomas (P), Art Ewoldt (SS), Dixie Walker (P), Fred Henry (1B), Joe Dowie (C), and George Winn (P); (back row) Henry Mattison (P), Ed Bogart (OF), Larry Gilbert (OF-MGR), and Oliver Tucker (OF). Not shown are Maurice Craft (P), Rube Robinson (P), and Eucal Clanton (1B). Clanton had been traded to Little Rock for Robinson. (Courtesy of Arthur O. Schott.)

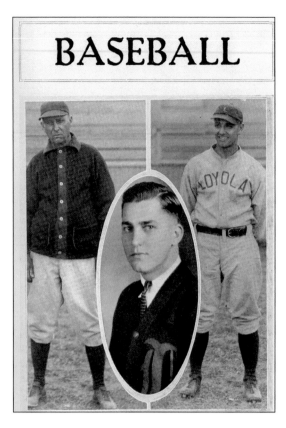

BASEBALL

LOYOLA UNIVERSITY 1924. In 1924, the Loyola University Wolfpack baseball club was led by (from left to right) Coach Bruce Hays, Manager Lastie Villien, and Capt. James Vorhoff. The school had encouraged baseball off and on for years, but it was not until they hired Bruce Hayes in 1923 that the program began to flourish. (Courtesy of Loyola University.)

SPRING TRAINING 1924. Posed in front of the grandstand at Heinemann Park, the 1924 edition of the New York Yankees were completing their third spring training season in the Crescent City. A 29-year-old Babe Ruth (middle row, sixth from left) led the American League with 46 home runs, 121 RBIs, 142 walks, and a .378 batting average. The Yankees finished the season two games behind Walter Johnson and the Washington Senators. This was the last Bronx Bombers spring training in New Orleans. From 1925 to 1942, St. Petersburg, Florida, became their spring home. (Collection of the author.)

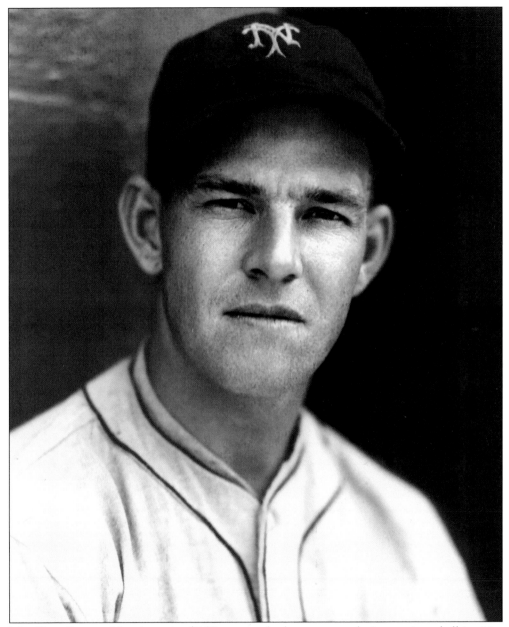

MEL OTT. Ott was 16 and earning $150 per month plus expenses playing semi-pro ball in cities near his hometown of Gretna (a suburb of New Orleans) when he was befriended by the owner of the Patterson Grays, lumberman-millionaire Harry Williams. In late August 1925, Williams met with New York Giant's manager John McGraw and told him about the young catcher. That evening Williams fired off a telegram to Ott telling him to report to McGraw at the Polo Grounds for a tryout on September 1. Believing one of his Patterson teammates was trying to pull one over on him, Ott ignored the telegram. When Williams returned a few days later, he was shocked to see Ott. He bought him a train ticket and almost had to drag him to the station. (Collection of the author.)

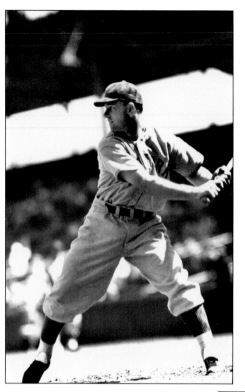

JUST KEEP HITTING THAT WAY, SON. Ott was often on the receiving end of friendly needling. The ribbing began early as teammates and scribes laughed at his unusual batting stance. By stepping high, then shifting his weight into the pitch with his bat swooping low and nearly upright, Ott constructed a swift, snapping action. Instead of making jokes, mentor and Giant manager John McGraw simply commented to Ott, "Just keep on hitting that way, son." (Collection of the author.)

MASTER MELVIN. For two years, Ott was planted on the bench next to his tutor, who did not want the youngster sitting with any of the veteran ballplayers. Though McGraw used him mostly as a pinch hitter (he led the National League with 46 pinch at-bats in 1927.) Dubbed "Master Melvin" by the New York press when he became a regular at the age of 19, Ott had career highs of 42 home runs and 151 RBIs the following year, 1929, when he led the league in walks for the first of six times. He played for 22 seasons until chronic leg problems forced him to stop—the ever-insightful McGraw had converted the teenage catcher into an outfielder to preserve his legs as long as possible. (Courtesy of The Diamond Club.)

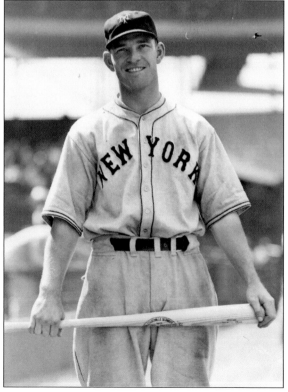

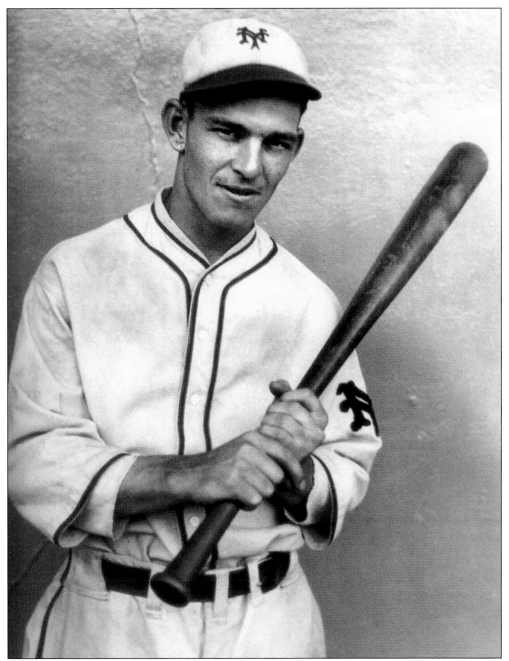

MEL OTT. Ott's left-handed power was perfectly suited to the Polo Grounds. He was the first National Leaguer to hit 500 home runs and was the all-time National League home run leader until passed by fellow Giant Willie Mays in 1967. He worked with ex-roommate and long time friend Carl Hubbell running the Giant's farm system until the end of his contract in 1950. He managed the Oakland Oaks in the Pacific Coast League (1951–1952) and was a Detroit Tiger broadcaster during the late 1950s. On a November night in 1958, returning home from dinner with his wife, his car was hit head-on by a drunk driver. The efforts of a team of doctors, including his son-in-law, kept him alive only a few days. (Collection of the author.)

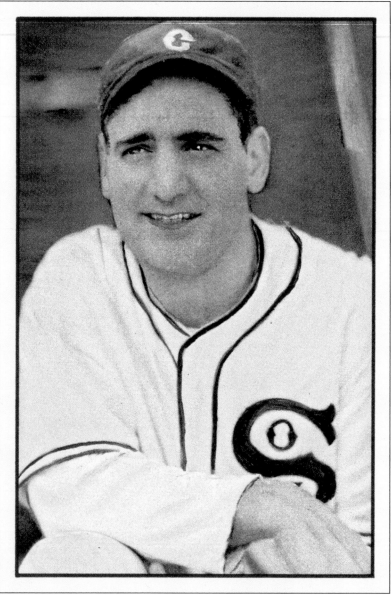

HENRY "ZEKE" BONURA. Affable and amusing, Henry "Zeke" Bonura was a local favorite who delighted his hometown fans with his antics while terrorizing opposing pitchers with his bat. He once stole home after misreading the signals from the opposing dugout. After becoming a college standout at Loyola University in New Orleans, he spent three years with the New Orleans Pelicans (1929–1931) and two with Dallas in the Texas League (1932–1933). He made his major league debut on April 17, 1934, with the Chicago White Sox, becoming their first true power hitter with 27 home runs. His defensive play, however, usually had fans covering their eyes. In 1936 he led all American League first basemen in fielding, mostly because he refused to go after easy grounders, waiving his Mussolini salute with his glove as balls rolled by untouched. Sub-par fielding, annual hold-outs, and rumors of a romantic interest in the owner's daughter caused his trade to Washington in 1938 and then to the New York Giants for $20,000 and two minor league players. (Courtesy of the Chicago White Sox.)

ZEKE BONURA. In the nightcap of a doubleheader against the Dodgers on July 2, 1939, at the Polo Grounds, Dodger player/manager Leo Durocher spiked Bonura as he crossed first base after grounding into a double-play to end the fourth inning. Bonura took off after Durocher, chasing him into right field where he finally caught up. After some wrestling and a few errant punches, both players were ejected from the game. The Giants would go on to win the game 6-4. In his seven seasons in the majors he posted a .307 batting average with 119 home runs. Bonura died in New Orleans on March 9, 1987, at the age of 78. (Collection of the author.)

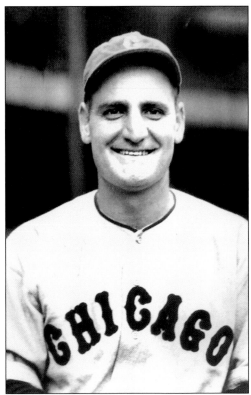

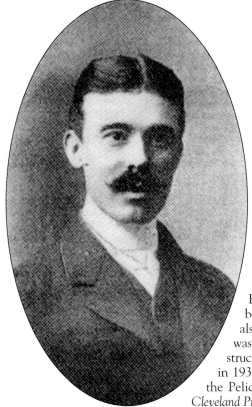

CHARLES SOMERS. One of the driving forces in the early years of baseball was Cleveland millionaire Charles Somers. Ban Johnson turned to Somers to get the league off the ground financially. At one point, Somers helped fund the White Sox, the Browns, and the Athletics while taking ownership stakes in the Cleveland Indians and the Boston Red Sox. He supplied the capital for Comiskey Park. His financial aid to Boston resulted in the team being called the Somersets in 1902. Somers was also a strong supporter of the farm system, which was still several decades away from being formally structured. Following the death of A.J. Heinemann in 1930, Somers purchased the controlling interest in the Pelicans from Heinemann's estate. (*Courtesy of the Cleveland Public Library.*)

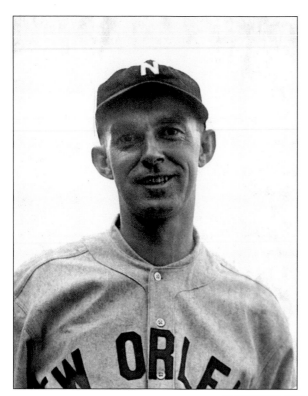

LARRY GILBERT. While he is most often remembered as the manager of the New Orleans Pelicans from 1923 through 1938, Larry Gilbert also had a successful playing career. After seven years in the major leagues, Gilbert joined the Pelicans in 1917. He won the Southern Association batting title (.349) in 1919 while roaming the outfield in Heinemann Park. A severe beaning in 1925 led to his retirement from the outfield, but he would lead the Pelicans to five Souther Association pennants (1923, 1926, 1927, 1933, and 1934.) (Courtesy of Helen Gilbert.)

EDDIE ROSE. On August 11, 1935, during a Sunday afternoon game against Birmingham, Pelican left fielder Eddie Rose hit a line drive off Baron's pitcher Legrant Scott that struck a low-flying pigeon. The bird died on the spot as Rose scampered to first base. He later had the pigeon mounted. Rose played for six seasons in New Orleans from 1931 to 1937. (Courtesy of Arthur O. Schott.)

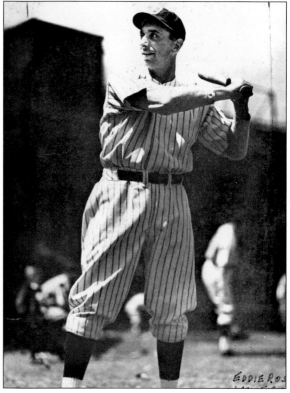

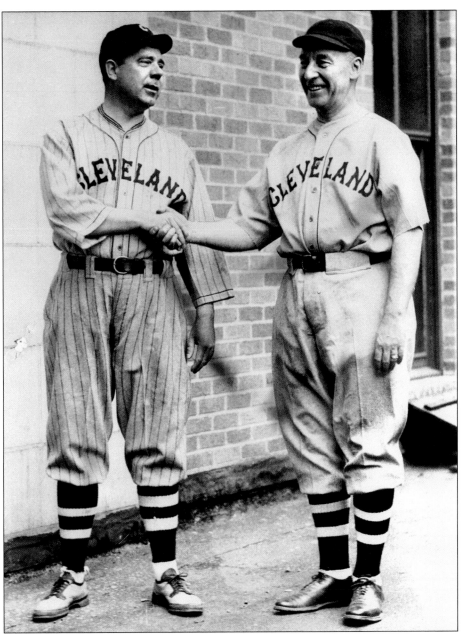

EVERY MAN A . . . FAN. Huey P. Long was the populist governor of Louisiana in 1931 when he posed for this photograph with the president of the Cleveland Indians, Alva Bradley. Long sports the home pinstriped uniform while Bradley dons the road uniform. Both are wearing their street shoes. The year before, Indians owner Charles Somers had purchased the New Orleans franchise from the estate of A.J. Heinemann and made the Pelicans their Class-A affiliate. Unlike many of their Southern Association opponents, the Pelicans were one of the most secure franchises in the league. Nevertheless, a little political exposure didn't hurt to ensure that the club remained in New Orleans. Long was later elected to the United States Senate and assassinated on September 8, 1935, in the lobby of the Louisiana state capitol building. (Courtesy Bettman/Corbis.)

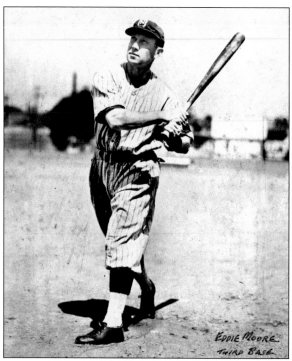

ED MOORE. Shortstop Eddie Moore had a 14-year career that included his 1933 championship season in New Orleans with the Pelicans, where he batted .309 with 5 home runs and 48 RBIs. (Courtesy of Arthur O. Schott.)

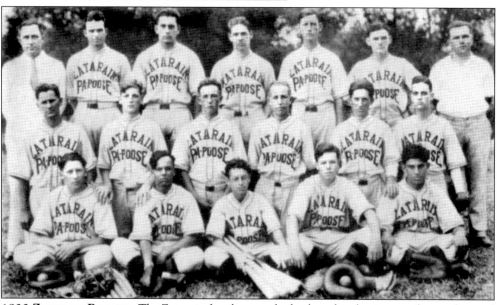

1933 ZATARAIN PAPOOSE. The Zatarain family owned a food product business and manufactured the popular Crab Boil seasoning. They also sponsored one of the most successful American Legion baseball clubs, the Papoose. This photograph shows the 1933 State American Legion championship. Pictured, from left to right, are (front row) Charles Coyle, Frank Gambino, John Sibel, Danny Mullen, and Lecky LeBlanc; (middle row) Al Boudreaux, Iggy Spies, Dan McGovern, Carroll Daigle, Ed Wendling, and Cyril Buchert; (back row) Charles Zatarain (sponsor), John Reid, Eddie Gatto (captain), Henry Willoz, Robert Craven, Earl Prattini, and Coach Al Kreider. (Courtesy of The Diamond Club.)

LOU BERGER. Between stints with the Cleveland Indians, Lou "Boze" Berger played second base for the New Orleans Pelicans on their back-to-back pennant winning teams in 1933 and 1934. He was selected as the team's MVP in 1934. After the outbreak of World War II, Berger joined the military and made that his career until 1962. (Courtesy of Arthur O. Schott.)

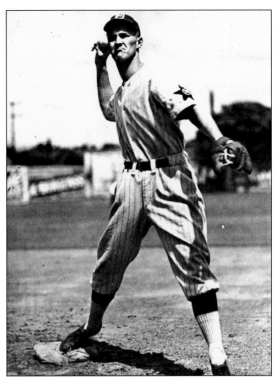

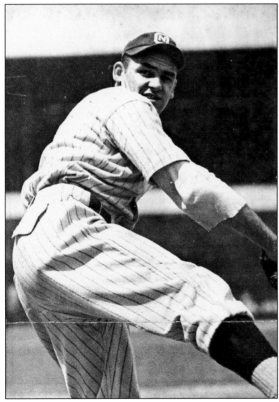

AL MILNAR. The gutsy left-hander won 46 games during his two seasons with the New Orleans Pelicans (1934–1935). During the 1934 season, Milnar had the lowest ERA (2.61) in the Southern Association. He racked up 17 consecutive wins in 1935 on his way to leading all Southern Association hurlers in wins (24), strikeouts (140), and winning percentage (.828). Milnar achieved his place in baseball history during the 1941 season when he became part of Joe DiMaggio's 56-game hitting streak, surrendering hits in games 17, 29, and 56. (Courtesy of Arthur O. Schott.)

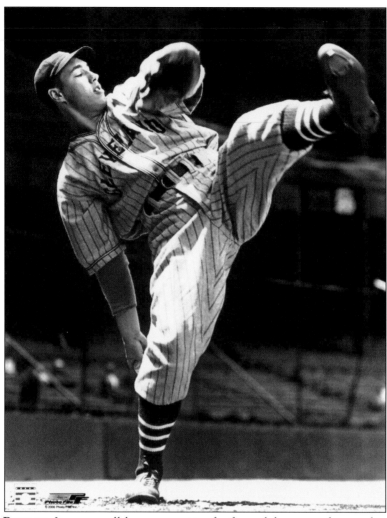

ALMOST A PELICAN. It was a well-known practice for farm clubs to warehouse players for the major league club, and the Cleveland Indians employed this strategy as well as any other team. In the spring of 1936, Cleveland scout Cy Slapnicka signed an Iowa farmboy, Robert Feller, for $1 and an autographed baseball. The 17-year-old high school junior was assigned to a farm club in Fargo-Moorehead where he was supposed to report after school ended. But Slapnicka, now promoted to general manager of the Indians, violated the rules by transferring Feller's contract to the New Orleans Pelicans. Feller did visit New Orleans for a brief time, being tutored in his rooms at the Roosevelt Hotel, but he never reported to the Pelicans, and in April of 1936 his contract was transferred to the Cleveland Indians. Eventually the paperwork shuffle caught up with Slapnicka when the owner of the Western League's Des Moines club, who had tried to sign Feller in 1935, protested to Baseball Commissioner Kennesaw Mountain Landis. After three months of hearings, Landis made it clear that he didn't believe anything Slapnicka or Indians President Alva Bradley said about the course of events, but he awarded Feller to the Indians anyway based partly on the testimony of Feller and his father, who wanted Bob to play for Cleveland. After paying a $7,500 fine, Cleveland now had their new right-handed fireballer. Feller made his major league debut on August 25, 1936, against the St. Louis Browns, striking out 15 batters on his way to a 4-1 victory. The rest, as they say, is history. (Collection of the author.)

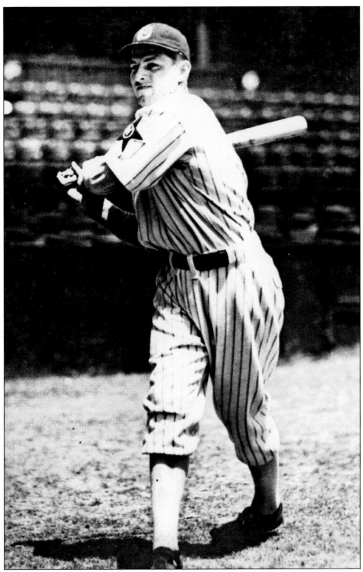

TOM HENRICH. Henrich roamed the cavernous outfield in Heinemann Park during his two seasons with the New Orleans Pelicans (1935–1936). He enjoyed his best year in 1936, smacking 15 home runs and 100 RBIs while hitting .346. His performance in New Orleans gained the attention of major league scouts. In April of 1937, Henrich was ruled as a free agent after Commissioner Landis determined that the Cleveland Indians had been hiding Henrich in their farm system. Many felt that Landis's ruling was payback for allowing the Indians to keep Bob Feller in a similar dispute in 1936. Four days after being released, Henrich signed with the New York Yankees. He played in the Yankee outfield from 1938 through 1950 with Joe DiMaggio and Charlie Keller. He helped contribute to six pennants, but injuries and military service (1943–1945) limited his World Series appearances to four. He was a key in one of the most famous Series games in Yankee history. In game four on October 5, 1941, with two men out in the inning, Dodger catcher Mickey Owen dropped a third strike on Henrich, allowing him to scamper to first base safely. Instead of a 4-3 Brooklyn victory, the Yankees would rally to win the game 7-4. (Courtesy of Arthur O. Schott.)

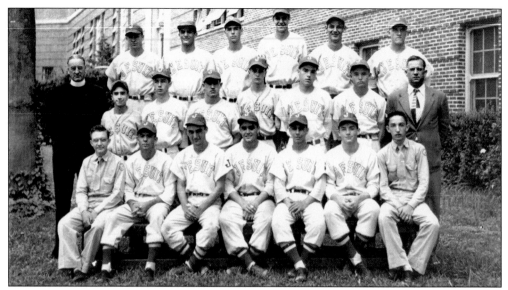

JESUIT HIGH SCHOOL BASEBALL. Jesuit High School is located on South Carrollton Avenue and Banks Street, across the street from where Pelican Park was located. Jesuit teams have captured state championships and produced several professional players. Under head coach Gernon Brown, the Blue Jays fielded two memorable squads. The 1936 edition (11-0) featured future major leaguers Connie Ryan (Boston Braves, Cincinnati Reds), Charlie Gilbert (Brooklyn Dodgers, Philadelphia Phillies), and John "Fats" Dantonio (Brooklyn Dodgers). Leading hurler Jesse Danna, along with Gilbert and D'Antonio, also starred with the New Orleans Pelicans. The 1946 squad (13-0), led by future New York Giant and New Orleans Pelican slugger Harold "Tookie" Gilbert, won the 1946 State Championship and also captured the American Legion World Series that summer. (Courtesy of the Historic New Orleans Collection.)

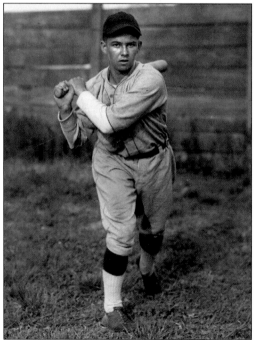

YOUNG CHARLIE GILBERT. In 1936, Charlie Gilbert was a member of Gernon Brown's state championship baseball team from Jesuit High School. Charlie and several of his teammates—notably Connie Ryan, Fats Dantonio, and Jesse Danna—would go on to play professional ball. (Courtesy of Helen Gilbert.)

ROY WEATHERLY. A native of Texas, Roy came up to the New Orleans Pelicans in 1935. He shuttled between the Pelicans and the Cleveland Indians for the better part of three seasons before catching on permanently with the Indians in 1938. As a Pelican, the rangy outfielder batted .306 from 1935 through 1937 with 16 home runs and 91 RBIs for manager Larry Gilbert. Weatherly spent 10 years in the majors with the Cleveland Indians (1936–1942), the New York Yankees (1943 and 1946), and the New York Giants, in an attempted comeback in 1950. (Courtesy of Arthur O. Schott.)

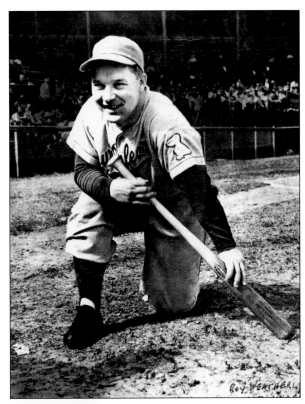

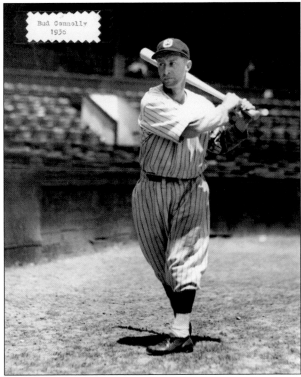

BUD CONNOLLY. Mervin "Bud" Connolly was a member of the New Orleans Pelicans from 1935 through 1937, anchoring an infield that included Harley Boss (first base), Dud Lee (second base), and Tom Hafey (third base). During his tenure with the Pels he batted .269 with 10 home runs and 193 RBIs. (Courtesy of Arthur O. Schott.)

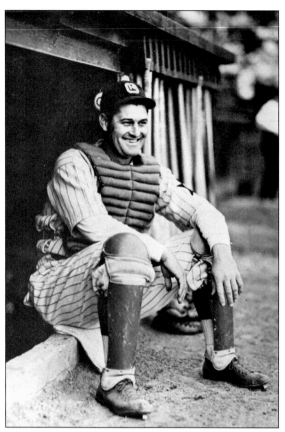

MARTIN "CHICK" AUTRY. A veteran of the Yankee and Indians organizations in the 1920s, Autry was the starting catcher for the New Orleans Pelicans for five seasons from 1932 until 1936. He died on January 26, 1950, at the age of 46 from a coronary thrombosis. (Courtesy of Arthur O. Schott.)

THE MAYOR'S BOX. Opening Day at Pelican Stadium on April 19, 1938, boasted a record crowd of 26,061 to establish a new Southern Association record. Among the notables in attendance were, from left to right, Lt. Neville Levy, William Helis, Col. Seymour Weiss, Mayor Robert S. Maestri, and Commissioner Joseph P. Skelly. Also shown are Little Rock manager Tommy Prothro and Pelicans manager Larry Gilbert. The Pelicans would conclude the 1938 campaign in third place, 10 games behind the Atlanta Crackers. Little Rock finished fifth, 15 games back. (Courtesy of the Louisiana State Museum.)

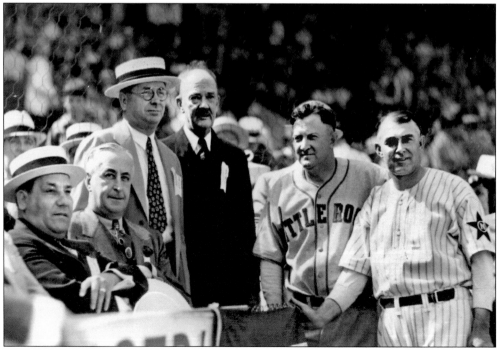

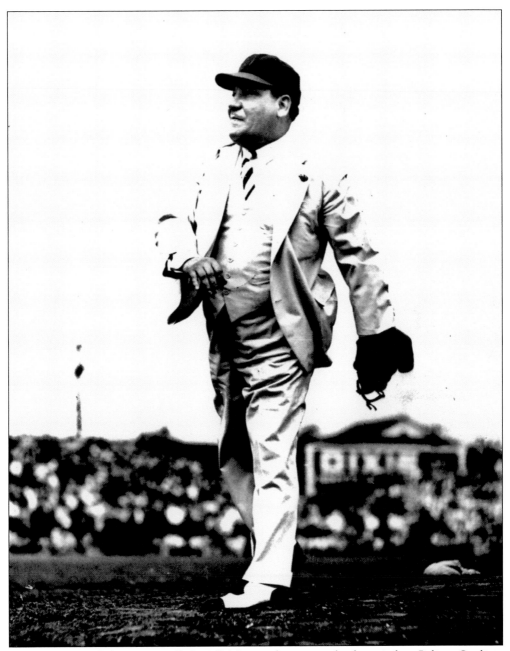

HIZZONER. New Orleans mayor Robert S. Maestri throws out the first pitch at Pelican Stadium on April 19, 1938, to open the season before a record crowd of 26,061 fans. The New Orleans Pelicans would defeat the Little Rock Travelers 10-4. An avid baseball fan, Maestri was rumored to have a minority interest in the Pelicans. (Courtesy of the Louisiana State Museum.)

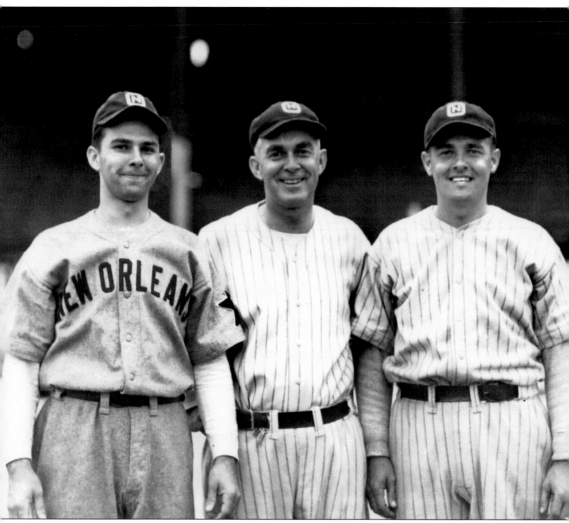

GILBERT AND SONS. Baseball was the family business, with Larry Gilbert (center) flanked by two of his three sons—Charlie (left) and Larry, Jr. (right)—shown here at Pelican Stadium in April of 1938. Charlie was a standout outfielder at Jesuit High School (Class of 1937) and played for two years with the Pelicans before moving up to the majors. He played for six seasons with the Brooklyn Dodgers, the Chicago Cubs, and the Philadelphia Phillies. He had a .982 career fielding average. The 1938 season was the only one in which the three Gilberts were all affiliated with the same team. (Courtesy of Helen Gilbert.)

JOHN BEAZLEY. This quiet Tennessee native was a journeyman pitcher whose stopovers included New Orleans from 1939 to 1941. He compiled a sub-par record of 17-15 with the Pelicans but went on to a sensational 1942 campaign with the St. Louis Cardinals, posting a 21-6 record and winning two games against the Yankees in the Cardinals-upset World Series victory. While serving with the air force during World War II, he injured his arm in an exhibition game against his old team and never fully recovered. In six years in the majors he was 31-12 with a 3.01 ERA. (Courtesy of Arthur O. Schott.)

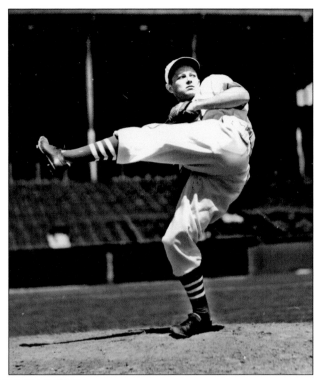

BATBOY TOOKIE GILBERT. A young Tookie Gilbert is shown in 1938 when he served as batboy for the New Orleans Pelicans that his father managed. The following year the family moved to Nashville. (Courtesy of Helen Gilbert.)

61

CHARLIE GILBERT. Born in New Orleans on July 8, 1919, the son of local baseball legend Larry Gilbert, Charlie Gilbert played outfield for six seasons between 1940 and 1947. He broke in with his father's Nashville Volunteers in the Southern Association in 1939, batting .317 with 14 home runs and 67 RBIs. After a brief stay with Montreal in the International League in 1940, Gilbert was called up and got his start with the Brooklyn Dodgers, debuting on April 16, 1940, on a team featuring Pee Wee Reese and Leo Durocher. He batted .246 with 2 home runs and 8 RBIs and was traded to the Chicago Cubs for the 1941 season. Over the next three injury-riddled seasons in Chicago, Gilbert did not fare much better (.279, .184, .150 respectively). He returned to the Nashville Volunteers for the remainder of the 1943 season, and the trip seemed to agree with him as he batted .328 with 7 home runs and 22 RBIS. After two years of military service, Gilbert returned to the majors with the 1946 Chicago Cubs but was traded to the Philadelphia Phillies after 15 games. He batted .242 for the Phillies in 1946 and .234 in 1947. Mostly a position player, he led the National League with 40 pinch at-bats in 1947. After a final season with Nashville Volunteers in 1948, he retired from baseball at the age of 28. Gilbert died in New Orleans on August 13, 1983, at the age of 64. (Courtesy of Helen Gilbert.)

OPENING DAY 1938. A record crowd of 26,061 packed Pelican Stadium on Opening Day to watch the New Orleans Pelicans best the visiting Little Rock Travelers by the score of 10-4 on April 19, 1938. (Courtesy of the Louisiana State Museum.)

FIFTH INNING

The War Years
1940–1959

Wars were fought on many fronts—in Europe, in the Pacific, and along racial lines. Even as the war effort drew more and more major leaguers into military service, owners still could not be persuaded to sign Negro League players. Instead, the All-American Girls Professional Baseball League, made famous by the movie A League of Their Own, *was formed in 1943 to satisfy the public's demand for baseball. The color barrier was not broken until 1947, when Jackie Robinson took the field with the Brooklyn Dodgers. Other teams were slow to adopt African-American and other minority players. It would be another 10 years before all of the teams had integrated, and it was not until the early 1960s that professional baseball could truly call itself integrated.*

Equally important in the game's chronology was the movement of teams from one city to another—the Braves moved from Boston to Milwaukee to Atlanta, the Browns from St. Louis to Baltimore, the Athletics from Philadelphia to Kansas City to Oakland, the Dodgers from Brooklyn to Los Angeles, and the Giants from New York to San Francisco. This activity helped spread baseball's influence beyond its Eastern and Midwestern roots.

Soon, jets would replace trains as the prime method of player travel, and national television broadcasts helped the game reach a wider audience. This, unfortunately, came at the expense of many minor league franchises that could no longer draw sufficient crowds to make the game a viable business enterprise.

These were turbulent times for baseball in New Orleans. Following the departure of long time manager Larry Gilbert, the Pelicans would have 17 different managers during the next 19 seasons. They would also change affiliations from the Cleveland Indians (1930–1939) to St. Louis Cardinals (1940–1942), the Brooklyn Dodgers (1943–1944), the Boston Red Sox (1946–1947), the Pittsburgh Pirates (1948–1956), and the New York Yankees (1957–1958).

Pelican Stadium was torn down in 1957 to make way for the Fontainebleau Motor Hotel, forcing the Pelicans to endure their last two seasons in City Park Stadium (now Tad Gormley). Despite moments of their former glory, attendance at Pelican games fell from 248,304 in 1949 to 71,577 in 1959. At the end of the 1959 season, the Pelicans were sold to Little Rock. While major league baseball enjoyed a post-war boom, the sport in the city was in decline as the sale of the Pelicans made New Orleans the largest American city without a professional baseball team.

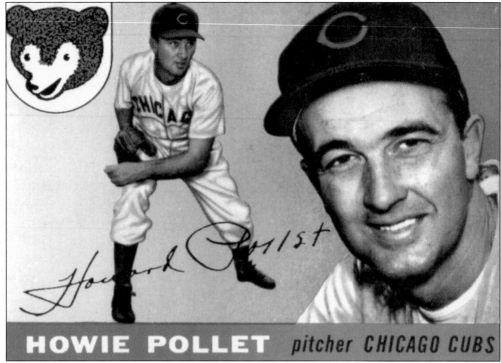

HOWIE POLLET *pitcher* CHICAGO CUBS

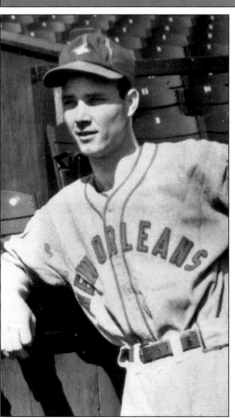

HOWIE POLLET. This native New Orleanian spent two years in the minors before making his major league debut at the age of 19 with the St. Louis Cardinals on August 20, 1941. He went on to become one of the premier left-handers in the National League, being named to three All-Star squads (1943, 1946, and 1949). He made a brief appearance in the 1942 World Series, pitching one-third of an inning against the New York Yankees. His 8 victories in 14 starts in 1943 earned him his first trip to the All-Star game. During his 15-year career he hurled 2,107 innings, winning 131 games against 116 losses with a 3.51 ERA. Pollet subsequently served as a pitching coach for the St. Louis Cardinals, winding up his career as a coach in Houston. After baseball Pollet spent 24 years in the insurance business in Houston. He died there at the age of 53 on August 8, 1974. (Collection of the author.)

VERN "TRADER" HORN. Trader Horn was a fixture at Pelican Stadium between 1940 and 1945, winning 66 games while losing 59 over five seasons. He was generally overshadowed by a pitching staff that included Al Jurisich and John Beazley. (Courtesy of Arthur O. Schott.)

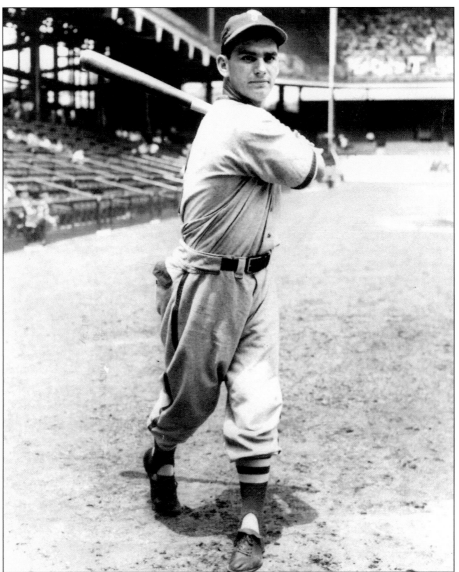

RALPH "PUTSY" CABALLERO. Born in New Orleans on November 5, 1927, Ralph "Putsy" Caballero was a star on his Jesuit High School team when he was signed by the Philadelphia Phillies at the age of 16 years. He made his debut with the Phillies at third base on September 14, 1944. Caballero still holds the major league record for being the youngest third baseman ever to play in the big leagues and is second only to pitcher Joe Nuxhall as the youngest player in all of major league baseball. Caballero was a member of the Phillies "Whiz Kids" in 1950, the youngest major league baseball team ever fielded. His teammates included pitcher Robin Roberts and a tremendous outfield consisting of Del Ennis, Dick Sisler, and Caballero's roommate, future Hall of Famer Richie Ashburn. They captured the National League pennant from the heavily favored Brooklyn Dodgers on the last day of the season, the Phillies' first pennant since 1915. Caballero played in three World Series games against the New York Yankees. During his 11-year career Caballero posted a .228 average with one home run and 40 RBIs during the course of 322 games. He retired from baseball in 1955. (Courtesy of Ralph Caballero.)

ALBERT E. BRIEDE. After pitching for St. Aloysius under Coach Danny Lyons in 1940, Briede was signed by the St. Louis Cardinals and assigned to their team in the Mountain State League (Class C). Following two years of military service (1942 and 1943), Briede was signed by the New Orleans Pelicans. He was optioned to Zanesville in the Ohio State League (Class D) but was recalled to New Orleans near the end of the season. He spent the entire 1945 season with the Pelicans, posting a 4-2 record under manager Fresco Thompson. His best season came in 1946 when he was signed by former Pelican Jake Atz to pitch for Natchez in the Evangeline League (Class D), where he posted a 16-5 record and a 3.73 ERA. An arm injury forced Briede to retire after the 1947 season. By 1949 he was back in semi-pro baseball in the Sugar Belt League, where he pitched for three years. In 1952 he retired from baseball for good. (Courtesy of Albert E. Briede III.)

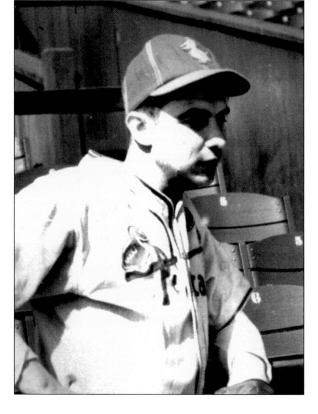

CARDEN GILLENWATER. Gillenwater was a solid defensive outfielder with the New Orleans Pelicans with good speed and a strong arm, which earned him a visit to the St. Louis Cardinals late in the 1940 season. Despite his offensive success in New Orleans (.305 in 1940, .273 in 1942, .333 in 1943) he had trouble catching on in the big leagues. In 1946 he tied a major league record with 12 putouts as an outfielder in a single game. (Courtesy of Arthur O. Schott.)

PEL HUGHES'S CONTRACT. James "Pel" Hughes was a native New Orleanian who had been an outstanding college athlete. The Pelicans signed him in 1945 for a $100 signing bonus and a salary of $175 per month. Shown here is his contract stipulating, among other things, that he was not required to travel with the team and would only play home games at night since he worked full time for the Illinois Central Railroad. As a result, he alternated with George Souter at third base. In 72 games he batted .303 with 1 home run and 49 RBIs. (Courtesy of Victor Hughes.)

SIMON SAYS. Coach Monk Simons (far right) shows his 1945 Tulane Green Wave hitters the finer points of holding the bat. The team's schedule was limited that year due to travel considerations imposed by World War II, but they managed to finish the season with a record of 27 victories with only 6 defeats, 4 of which came at the hands of intrastate rival LSU. (Courtesy of Tulane University.)

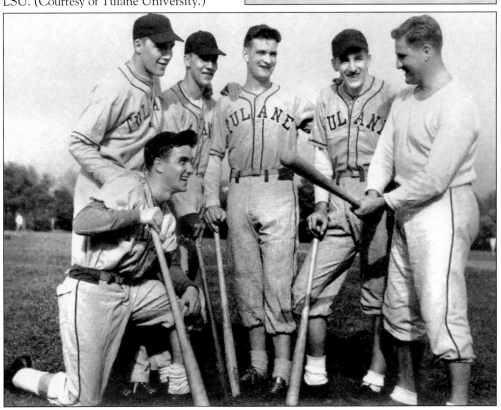

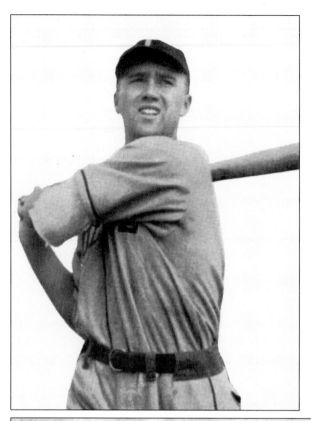

BOBBY BROWN. A standout on the 1945 Tulane University baseball team, Bobby Brown would complete his education in New Orleans and sign with the New York Yankees for a substantial bonus in 1947. His rookie year, Brown hit .300 in 69 games and led the American League in pinch hits (9). During 113 games in 1948 he again hit .300 but was platooned at third base due to his sub-par fielding. Despite this, Brown went on to star in four World Series with the Yankees, producing key hits in the 1947 and 1949 contests against the crosstown rival Brooklyn Dodgers. In the off-season Brown enrolled in medical school and, after losing two years to military service, retired from baseball in 1954 to practice medicine. In 1984 he left his medical practice to replace Lee MacPhail as president of the American League, a position he held for the next 10 years. (Courtesy of Tulane University.)

New Orleans Public School Students' Annual Benefit Baseball Game

N⁰ 17496

Service Teams vs. Pelicans

PELICAN STADIUM

Tuesday, April 13th, 1:30 P. M.

Admission - - - - 15c

PELICAN BENEFIT GAME. Severe travel restrictions imposed during wartime meant that many of the major league teams that came through New Orleans were not available for pre-season games. The Pelicans were challenged by a Naval Reserve team stationed in Mississippi to benefit the New Orleans Public Schools. (Collection of the author.)

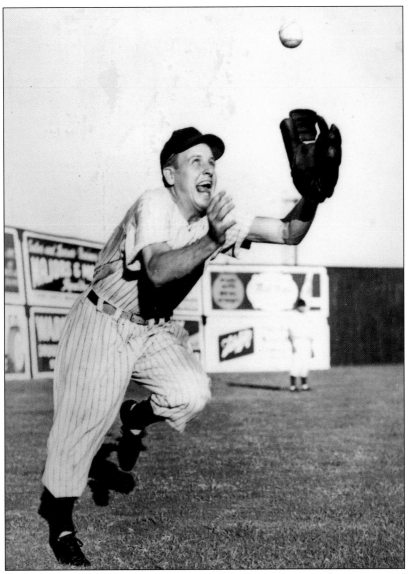

EDWIN PALMER. Having cut his teeth as an outfielder for the city champion 1940 Zatarain Papoose squad coached by Al Kreider, New Orleans native Edwin Palmer went on to play for both LSU (1942–1943) and Tulane (1944). After military service he tore up the East-Texas League, batting .330 for Greenville in 1946. The following season he led the Big Sate League in stolen bases (62), and his solid fielding set marks for putouts, assists, double plays, and fielding average, all while turning in a .321 batting average. In his two years in Greenville he totaled 355 hits, 11 home runs, 155 RBIs, and 110 stolen bases. During the off-season, a group of local all-stars faced Cleveland pitching ace Bob Feller's all-star crew in an exhibition played at Pelican Stadium on October 11, 1947, which the local team won 3-2. The press credited Palmer with running down a ninth-inning drive by Andy Pafko (Chicago Cubs) to save the game. Local newspaperman and Detroit Tiger scout Hap Glaudi recommended Palmer to the organization and in 1948 he was signed and assigned to the Dallas Rebels in the Texas League. In 56 games he batted .242. After baseball, Palmer owned and operated a successful paper distribution business in New Orleans. (Courtesy of Edwin Palmer.)

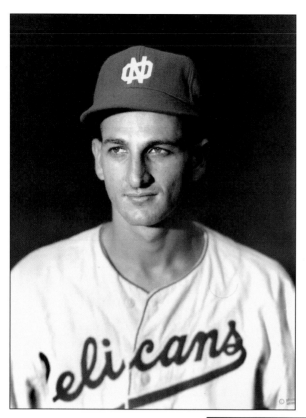

MELVIN RUE. Mel Rue played 597 games at shortstop and 69 games at second base for the New Orleans Pelicans for six seasons from 1944 through 1949. While known for his solid defense, he was also a fair hitter, averaging .255 during his career with the Pelicans. After 22 years Rue retired from baseball after the 1954 season. He returned to the New Orleans area and now lives in Kenner, Louisiana. (Collection of the author.)

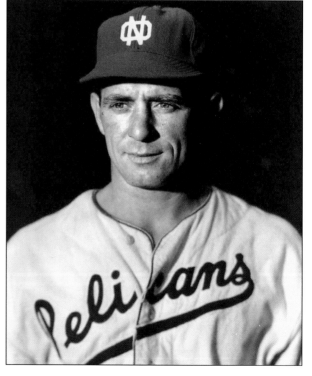

PETE KRAUS. Pete Kraus played for six teams during 10 seasons (1937–1950) with a four-year hiatus for military service. Three of those years were spent with the New Orleans Pelicans (1947–1949), where he batted .286 with 8 home runs and 128 RBIs. He retired from baseball after the 1950 season. (Courtesy of Lenny Yochim.)

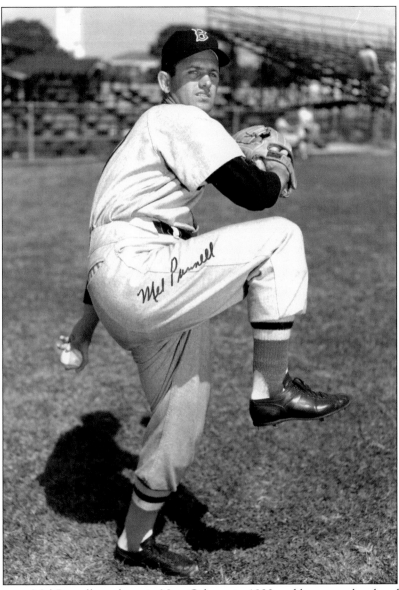

MEL PARNELL. Mel Parnell was born in New Orleans in 1922 and became a local and national hero as one of the most successful left-handers in Boston Red Sox history (1947–1956). With its imposing Green Monster in left field, the crafty southpaw handled right-handed hitters with baffling inside sliders. He posted a career record of 70-30 at home in Fenway Park. In 1949 he was the American League's leader in wins (25) and ERA (2.77). He won 18 games in each of the next two seasons. After an off-year in 1952, he rebounded with a 21-8 mark in 1953. Parnell struggled with a bad elbow for three more years before retiring, but in his final season he threw the Red Sox' first no-hitter in 33 years on July 14, 1958. He returned to New Orleans in 1958 to breathe some life back into a failing New Orleans Pelican franchise, but not even a hometown hero could overcome average talent, no professional affiliation, and a declining fan base. Nevertheless, Parnell led his team to a 68-71 record in the Pelican's final season. He retired from baseball altogether and became a successful businessman, but he remains a popular local fixture on the baseball scene in New Orleans. (Collection of the author.)

AL KOZAR. After three years of military service (1943–1945), Al Kozar returned to baseball in 1946 with Scranton in the single-A Eastern League. He came to New Orleans in 1947 to play second base for the Pelicans, where he hit .339 in 147 games, with 2 home runs and 75 RBIs—good enough to earn him a trip to the Washington Senators in the American League. Kozar spent 1948 and 1949 with the Senators and was traded in during the 1950 season to the Chicago White Sox, but by then his major league career was over. He spent the next four years with various minor league teams, before finally retiring in 1954. (Collection of the author.)

TOM WRIGHT. After three years of military service, the North Carolina native came to the New Orleans Pelicans for the 1947 season under player-manager Fred "Whale" Walters. Wright hit .325 during 133 games in an outfield that featured George Stumpf and Ed Lavigne. He spent nine seasons in the major leagues, mostly as a pinch hitter. (Collection of the author.)

Jim Shea. Jim Shea was a promising young pitcher who broke in with the New Orleans Pelicans in 1946, winning 11 games with only 7 losses (.611) in his inaugural campaign. He finished 1947 with a record of 9 wins and 5 losses (.643) with a 3.55 ERA before injuries finally took their toll. Shea spent 1948 with Louisville but retired after the 1948 season. (Collection of the Author.)

Al Flair. Another in a series of native New Orleanians to play for the Pelicans, the six-foot four-inch first baseman spent the 1947 and 1948 seasons in New Orleans, where he led the Southern Association in home runs (24) and RBIs (128) during the 1947 campaign. He led the team in 1948 with 22 round trippers and a .348 average. During a career spanning 14 seasons from 1937 through 1957, Flair played a scant 10 games in the majors with the Boston Red Sox in 1941. After retiring, Flair became a successful businessman in New Orleans. He died there on July 25, 1988, one day after his 72nd birthday. (Courtesy of Arthur O. Schott.)

73

JIM ATKINS. Atkins spent the better part of three seasons with the New Orleans Pelicans, from 1947 to 1949, before being traded to the Birmingham Barons. He would post 29 wins and 25 losses during that time. Atkins made two brief appearances in the majors with the Boston Red Sox in 1950 and 1952 before returning to the minors. He retired from baseball in 1957. (Courtesy of Lenny Yochim.)

GEORGE STUMPF. New Orleans native George Stumpf enjoyed an 18-year career in professional baseball, mostly in the American Association. He spent four seasons in the majors in the 1930s, playing 118 games in the outfield for the Boston Red Sox and the Chicago White Sox. Stumpf returned to New Orleans for the 1947 season where he batted .299 with 5 home runs and 68 RBIs. He died in Metairie, Louisiana, on March 6, 1993, at the age of 82. (Collection of the author.)

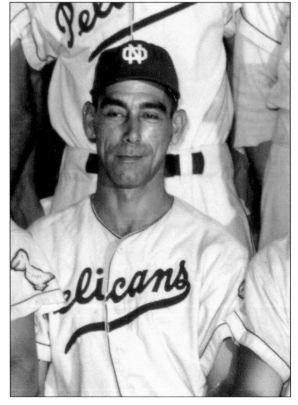

I Love a Parade. The New Orleans Recreation Department (NORD) band leads a parade down Canal Street in downtown New Orleans to mark the opening of baseball season in 1947. (Courtesy of the New Orleans Public Library.)

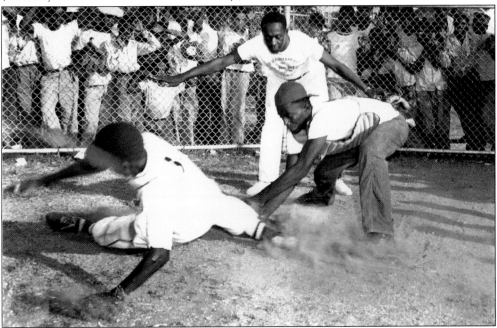

Safe! An unidentified member of the New Orleans Creoles demonstrates the proper way to slide into home plate to a group of neighborhood kids attending a baseball clinic at Pelican Stadium in 1947. The Creoles were one of several black clubs that called New Orleans home. Others included the New Orleans Black Pelicans, the New Orleans Stars, and the New Orleans Eagles. (Courtesy of the New Orleans Public Library.)

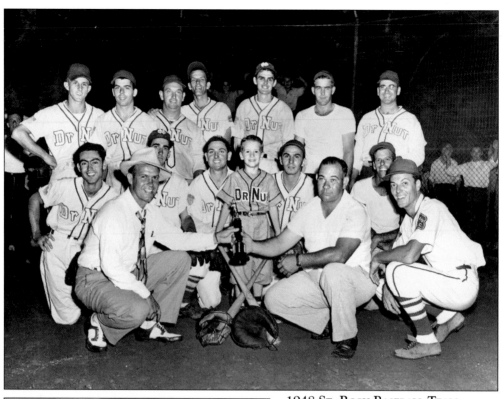

1948 ST. ROCH BASEBALL TEAM.
This photo shows the 1948 St. Roch Playground baseball team, champions in the New Orleans Recreation Department (NORD) Playground League. Henry "Dunk" Beter (front left in hat and tie) of NORD is presenting a trophy to Coach Herb Retif of the championship team. There were dozens of such playground leagues across the city. The team's uniforms bear the name of the team's sponsor, Dr. Nut, a popular soft-drink at that time in New Orleans. (Courtesy of the New Orleans Public Library.)

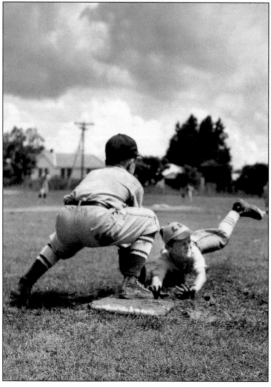

YER OUT! This photograph by Life magazine photographer John Dominis accompanied a September 5, 1949, article congratulating New Orleans on its children's recreation program. The game is taking place at NORD's Perry D. Roehm Stadium on Abundance Street in August of 1949. The Mohr Plumbing first baseman applies the tag to an unknown opponent. (Courtesy of the New Orleans Public Library.)

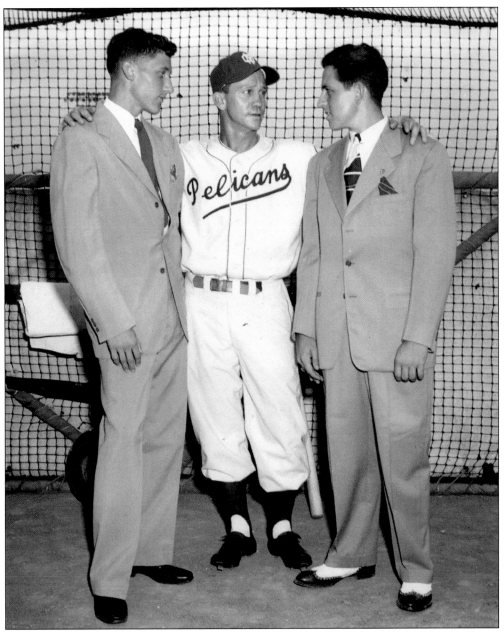

LOCAL FAVORITES. New Orleans Pelican manager Jimmy Brown shares a moment with two local favorites, Maurice Edwin "Moon" Landrieu (left) and Larry Lassalle (right), at Pelican Park in 1948. Both young men finished successful senior seasons as pitchers for the Jesuit High School baseball team. Lassalle went on to have the proverbial cup of coffee in the majors during a brief stay in the Pirates organization, but he never saw time in the show. Landrieu entered Loyola University in New Orleans and led his team to the 1952 All-Gulf States Conference championship. He graduated from law school and entered New Orleans politics, becoming a city councilman and eventually being elected mayor of New Orleans (1970–1978) and serving as Secretary of Housing and Urban Development (HUD) in the Carter administration. He retired from public life in 2000. (Courtesy of Maurice Landrieu.)

LENNY YOCHIM. Born in New Orleans on October 10, 1928, Lenny Yochim broke in with New Iberia of the Evangeline League at the age of 19, winning 20 games and batting .343 with 7 home runs. He came to the New Orleans Pelicans in 1948 and spent nearly 9 seasons with his hometown club, piling up 60-50 record. Yochim once tallied a round-tripper on a bunt, as the errant throw to first was lodged in a gopher hole beneath a bench on the right field stands. (Courtesy of Lenny Yochim.).

PIRATE PITCHER. Yochim was one of a score of former Pelican pitchers to be called up to the Pittsburgh Pirates; others included Elroy Face, Vern Law, and Paul LaPalme. Yochim made two trips to the majors (1951 and 1954) as a pitcher, but after retiring at the end of the 1956 season, he spent the remainder of his career in the Pirate organization evaluating, instructing, and scouting players. (Courtesy of Lenny Yochim.)

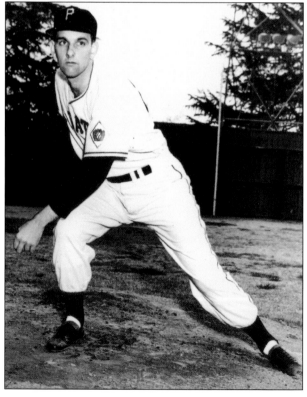

THE NEIGHBORHOOD PASTIME. The popularity of baseball among the New Orleans African-American community reaches back to the 1860s when several amateur teams were active in leagues throughout the city. The Dumonts, the Orleans, the Aetnas, the Fischers, and the Unions were all mentioned in the press of the day. There was even a Southern League of Colored Base Ballists formed in 1886 in New Orleans. This picture by photographer Roy Trahan from the 1950s shows a group of kids from a mid-city neighborhood called Gert Town playing baseball in the street. The batter is using what appears to be an old table leg as a bat. Bases are nothing more than hubcaps and pieces of wood. Despite their meager resources, it's the game that is important to these kids, as it always has been to children on side streets and playgrounds across the country. (Courtesy of the Historic New Orleans Collection.)

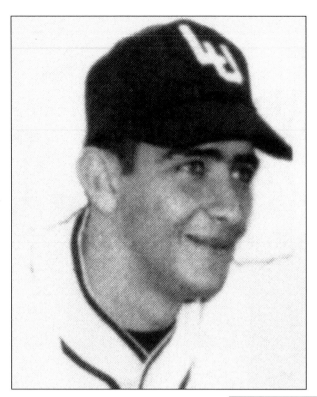

MARION "DOOKIE" DAUPHIN. Born in New Orleans on August 13, 1932, Dauphin was a three-sport standout at Redemptorist High School, where he was All-Prep in football and baseball. He was granted a baseball scholarship to Loyola University under Coach Jack Orsley in 1951. During his four years with the Wolfpack, Dauphin compiled a career average of .325 and twice led the club in home runs and RBIs. His senior year he hit for a .402 average and smacked three consecutive bases-loaded homers in three games—two against Southeastern University and one against LSU. Following his military service Dauphin retired from baseball and entered the workforce at New Orleans Public Service (NOPSI) where he was employed for 27 years. (Courtesy of Loyola University.)

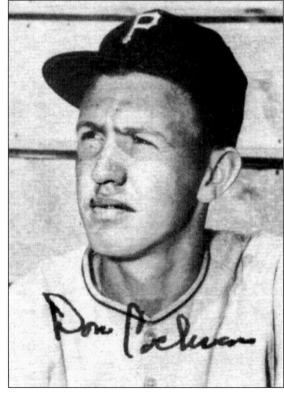

DON COCHRAN. Don Cochran had four years in organized baseball, two of them with the New Orleans Pelicans in 1952 and 1953. He tossed a career record of 33 wins and 14 losses with a 3.66 ERA. (Collection of the author.)

GENE FREESE. A powerful bat brought this West Virginia native to the New Orleans Pelicans in 1954, along with his older brother George. They patroled the infield at Pelican Stadium at second and third base respectively, but it was Gene's bat that would make the difference in his career. While with the Pelicans, Freese batted .332 with 16 home runs and 98 RBIs, helping manager Danny Murtaugh to a second place finish. It got the attention of the Pirates, and he played the following season in Pittsburgh, once again alongside his brother George. He currently makes his home in New Orleans. (Collection of the author.)

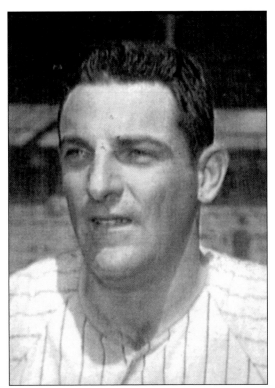

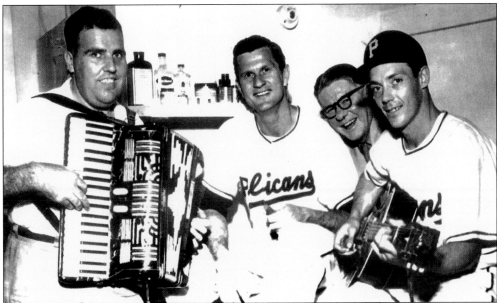

CLUBHOUSE CROONERS. With trainer Angelo "Tiny" Tunis on the accordion, outfielder Erv "Four Sack" Dusak and WTPS broadcaster Ted Andrews on vocals, and hurler Elroy Face on guitar, this unlikely group provided post-game entertainment for the 1954 Pelicans. Dusak spent nine seasons with the St. Louis Cardinals and the Pittsburgh Pirates (1941–1952), while Face would go on to a notable 14-year career with the Pirates and the Detroit Tigers. (Courtesy of Lenny Yochim.)

ELROY FACE. After four years in the minors, Elroy Face made his debut with the Pittsburgh Pirates on April 16, 1953. He pitched 119 innings on his way to a 6-8 record, with a 6.58 ERA. The Pirates sent Face to New Orleans in 1954 under third-year manager Danny Murtaugh for seasoning and he put together a 12-11 record in 25 starts. The remainder of his appearances (15) were in relief as both a middle man or closer—a new role for pitchers—and it suited him well. Face returned to the Pirates in 1955 and spent the next 14 years as mostly a relief pitcher. With the Pirates he was 104-95, with 193 saves. He was named to three All-Star squads (1959, 1960, and 1961). His deadly forkball and quick pick-off move helped dismiss the idea that relievers were nothing more than failed starters. In 1959, Face established two major league records that still stand today; one for winning percentage (.947), when he went 18-1, and another for consecutive wins by a reliever (22 over two seasons). His role as a closer was featured during the 1960 World Series against the Yankees when Face chalked up three saves in four games during 10.1 innings. His performance was overshadowed by Bill Mazeroski's ninth-inning home run in game seven that brought Pittsburgh its first World Series title since 1925. He retired from baseball in 1970 and became a full-time carpenter. In 1979 he was the carpentry foreman at Mayview State Hospital in Pittsburgh until he retired from that position at the age of 51. (Collection of the author.)

SLIDE INTO THIRD. An unidentified New Orleans Pelican player shows a group of NORD youngsters how to slide into third base during a baseball clinic held in 1955 at Pelican Stadium. Note his elevated right foot, spikes up—intended to either intimidate the opposing third baseman making the tag or to knock the ball out of his glove. (Courtesy of the New Orleans Public Library.)

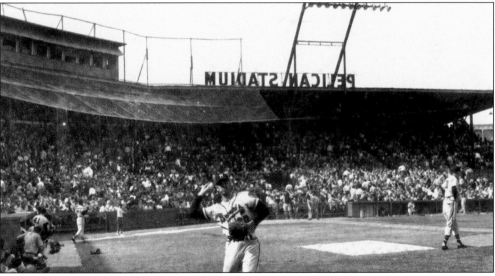

EXHIBITION GAMES. Since 1869 New Orleans has played host to professional teams who toured the country. This image shows the Milwaukee Braves playing the Brooklyn Dodgers at Pelican Stadium on March 31, 1955. The Braves featured Hank Aaron, Joe Adcock, Eddie Mathews, Johnny Logan, Lew Burdette, and Warren Spahn. The Dodgers were loaded with notable players, among them Roy Campanella, Duke Snider, Gil Hodges, Pee Wee Reese, Jackie Robinson, Carl Erskine, Sandy Koufax, and Don Newcombe. Also on the Brooklyn roster was George Shuba, who had played with the New Orleans Pelicans in 1944. (Courtesy of the New Orleans Public Library.)

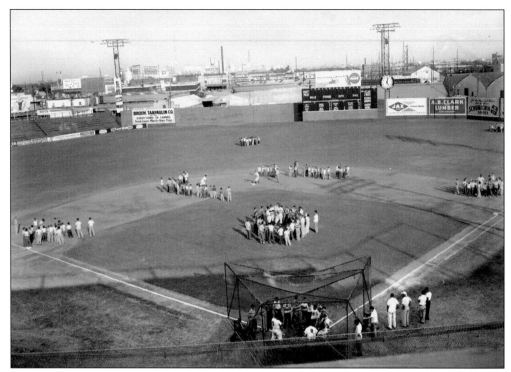

PELICAN BASEBALL CLINIC. Groups of local kids surround players from the New Orleans Pelicans at every position during this 1955 baseball clinic at Pelican Stadium sponsored by NORD. In addition to learning the principles of pitching, hitting, fielding, and base running, youngsters spent 15 to 20 minutes with each player learning the basics of that position. (Courtesy of the New Orleans Public Library.)

An Indian's Fan ... I Hope.
Comedian Bob Hope came to
New Orleans on July 14, 1955, to
play in a golf match at Lakewood
Country Club to benefit the United
Cerebral Palsy Association. When
it had to be called off because of
bad weather, Hope, a long time
baseball fan and part-owner of
the Cleveland Indians, made two
personal appearances at the Saenger
Theater on Canal Street instead.
During the day, he also found time
to clown around with a young
NORD baseball player. (Courtesy
of the New Orleans Public Library.)

Earl Weaver. Another former
Pelican player elected to the
Hall of Fame was Earl Weaver,
second baseman on the 1955
and 1956 Pelican clubs under
manager Andy Cohen. He
never made it to the majors
as a player, but he did make it
as a manager. He was elected
as a manager to the Hall of
Fame in 1996 by the Veterans
Committee in recognition
of his stormy, yet successful
stewardship of the Baltimore
Orioles from 1968 to 1982
and again in 1985 and 1986.
(Collection of the author.)

A **LITTLE RUSTY.** An 11-year old Daniel Staub posed for this picture at Kirsch Rooney Park on July 18, 1955. He would later attend Jesuit High School, where he was nicknamed "Rusty" for his bright red hair. He would have a 23-year career in professional baseball. (Courtesy of the New Orleans Public Library.)

RAY YOCHIM. Raymond Austin Aloysius Yochim, the older of the two Yochim brothers, spent 15 years in organized baseball interrupted by three years of military service (1943–1945). The New Orleans native made two brief appearances in the majors with the St. Louis Cardinals in 1948 and 1949 and compiled a career record of 78 wins and 95 losses He was a player-manager for the New Orleans Pelicans in 1958 for the second half of the season. He died at the age of 79 in New Orleans on January 26, 2002. (Courtesy of Lenny Yochim.)

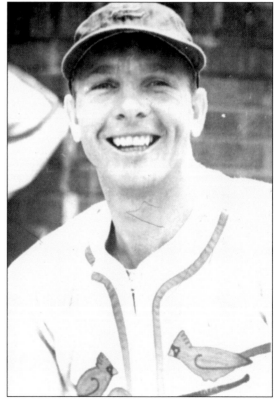

NORD Players. Among the players participating in the 1956 NORD summer league for United China were Freddie Nunez (kneeling), Andrea Capaci (left), Bobby Breuhl (back), and Donald Cassara (right). A local department store chain, Maison Blanche, was the league sponsor, which is why they have the letters "MB" on their caps. United China was a wholesale company that imported everything from fine china for local restaurants to novelty salt and pepper shakers sold in dime stores. (Courtesy of the New Orleans Public Library.)

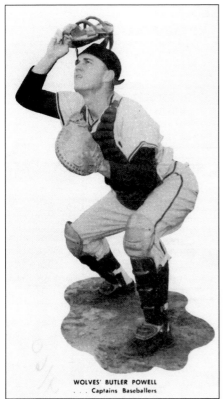

WOLVES' BUTLER POWELL
. . . Captains Baseballers

The Butler Did It. New Orleans native Butler Powell was an All-State catcher at St. Aloysius High School, catching the eye of Loyola skipper Rags Scheuermann. Powell became the starting catcher for Loyola University from 1956 until 1960. During his tenure, the Wolfpack compiled an overall record of 46-24. He finished the 1958-1959 season with a .354 average, earning the school's Sports Citation award. Named captain for his senior year, the Pack finished with a 16-2 record. Following graduation, Powell signed with the Milwaukee Braves organization. He and his family make their home in the New Orleans area. (Courtesy of Loyola University.)

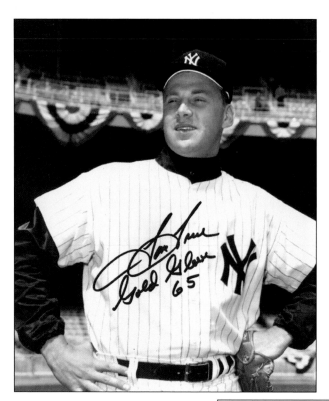

TOM TRESH. Tresh, the son of former major league catcher Mike Tresh, spent 33 games at third base for the 1958 New Orleans Pelicans, batting .250 and showing little promise—an inauspicious start for a young man who would become the American League Rookie of the Year in 1962, hitting .286 with 20 home runs and 93 RBIs as a switch-hitting Yankee shortstop when Tony Kubek served in the military. Moved to left field in 1963 when Kubek returned, he continued to hit homers, three times topping 25, but his batting average declined steadily. A damaged knee in 1967 hastened the end of his career. (Collection of the author.)

HAROLD "TOOKIE" GILBERT. Son of local baseball legend Larry Gilbert, Tookie Gilbert was recruited and signed by Mel Ott to the New York Giants in 1946 for $50,000. After several years in the Giants' minor league organization, Gilbert made his major league debut on May 5, 1950, homering against the Pittsburgh Pirates. He finished his career with the New Orleans Pelicans batting .261 with 22 home runs in 1959. He was elected civil sheriff of Orleans Parish in 1962. Gilbert died at the age of 38 on June 24, 1967, of an apparent heart attack while driving his car.

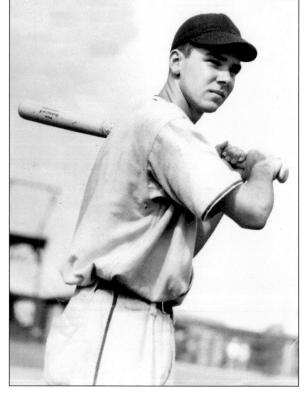

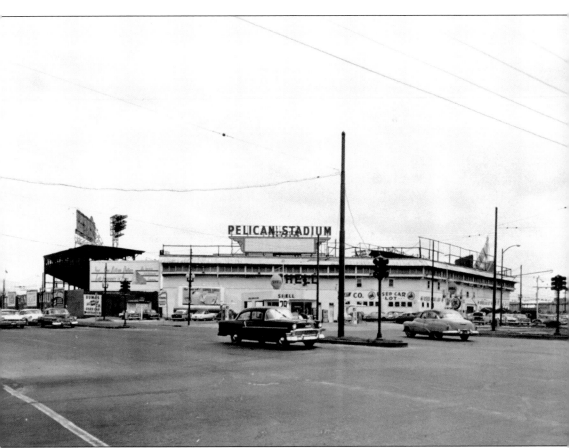

PELICAN STADIUM. Home to the Pelicans for 45 years, Pelican Stadium also played host to numerous major league teams who would play exhibition games during spring training or on their way back north from other cities. The Pelicans played their final game in this ballpark on September 1, 1957, in front of a mere 941 fans who watched them lose to the Memphis Chickasaws by the score of 7-3. The stadium was torn down in 1957 to make way for the Fontainebleau Motor Hotel. The Pelicans played their final two seasons at City Park Stadium (now Tad Gormley Stadium). (Courtesy of the Historic New Orleans Collection.)

JUST LEAVE THE DOOR OPEN. The editorial cartoons of John Chase delighted New Orleanians for years when this one appeared in the *New Orleans States-Item* newspaper shortly after it was reported that the franchise had been sold and was relocating to Little Rock. Chase's familiar mustachioed-man representing the people of New Orleans is shown at the tomb of the Pelicans, whose namesake is asking that the city leave the door open, hoping the team could return to the city in the future. It was not to be, as the Southern Association folded a year later. Declining attendance at the ballpark combined with the growing popularity of watching baseball on television led to the league's demise. (Courtesy of the Historic New Orleans Collection.)

RUSTY STAUB. Daniel Joseph Staub was born in New Orleans in 1944. A high school phenomenon at Jesuit, Staub signed with the Houston Colt 45s (renamed the Astros) for $132,000 in 1961 and played 150 games as a 19-year-old rookie. He and Ty Cobb are the only players to hit home runs before the age 20 and after age 40, and Staub is the only player in major league history to appear in 500 games for four teams and collect 500 hits for four teams. His short, left-handed stroke produced line drives and a .333 average for the Astros in 1967, with a league-leading 44 doubles. (Collection of the author.)

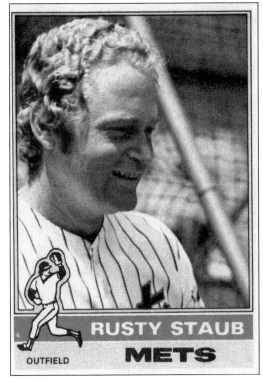

LE GRANDE ORANGE. Always popular with the fans, Staub became a national hero in Canada as a star for the expansion Montreal Expos. The French-speaking Canadians nicknamed him Le Grand Orange for his red hair. He rewarded them with 30 homers in 1970. A broken hand, his first major injury, sidelined him with the Mets in 1972, but he played a dramatic role in the post-season in 1973. Once called a pure hitter by Hall of Famer Duke Snider, Staub retired with 2,716 hits, 1,466 RBIs, and an unmatched reputation as a batter. The Mets made him a pinch hitter in his final few years. He tied records in 1983 for consecutive pinch hits (8) and RBIs (25), and he had a record 81 pinch at-bats (he hit .296). (Collection of the author.)

A Pure Hitter. One sportswriter quipped that Staub led the league in idiosyncrasies. He would often send his food back at restaurants and was more interested in fine wine and gourmet food than a night on the town with the guys. He parlayed his interest in cooking into a successful New York restaurant he operated for many years. After selling it, Staub entered the wine business. His label, Le Grand Orange, produced above average wines for many years. The tragedy of September 11 caused Staub to return to New York to become more involved with the charitable foundation he helped establish, the New York Police & Fire Widows' & Children's Benefit Fund. He also spends time working on behalf of the Rusty Staub Foundation, which provides inner-city kids with scholarships and assistance funding meal programs in New York City. Overlooked by the Baseball Writers Association due to his role as a designated hitter, Staub will be eligible for consideration for the Hall of Fame by the Veterans Committee in 2004. (Collection of the author.)

SIXTH INNING

The Rough Years
1960–1969

While major league baseball was booming, its growth came at the expense of minor league franchises. Like many New Orleanians, I could only watch my favorite teams on television. Its growing popularity brought big league baseball, broadcast by Dizzy Dean and Pee Wee Reese, into the living rooms of millions of Americans, prompting the decline of attendance at minor league ballparks across America. In 1960, the beleaguered Southern Association folded.

In 1961, millions of viewers were glued to their televisions watching Roger Maris and Mickey Mantle chase Babe Ruth's sacred home run record. Expansion teams, including the Los Angeles Angels and a revamped Washington Senators, took the field for the first time. New Orleans felt a collective sense of pride when local Jesuit High School star Daniel "Rusty" Staub was signed by the expansion Houston Colt 45s in 1962. The proximity of Houston to New Orleans, and a growing alliance in the petroleum industry between the two cities, allowed many fans to adopt the Houston franchise as the closest thing to having their own team.

Professional baseball players had organized several times in baseball history, but they were never able to make the advances that unions in other industries had won for their members. The Major League Baseball Players Association had been around for more than 30 years, but its sole purpose had been to collect and administer a meager pension. Concerned about getting a piece of the growing television revenues, the players sought to strengthen their union in 1965 by hiring veteran labor organizer Marvin Miller. He knew there was more at stake than adding broadcasting money to the pension fund. For one thing, the minimum salary was $6,000, just a thousand dollars more than it had been in 1947. As he began to collect data, players were surprised at how poorly they were being paid. This education paved the way for the first collective bargaining agreement in 1968.

Baseball fans in the Crescent City turned to their local high school and college teams for live ballgames and these programs began to thrive. But young New Orleanians and teenagers across America seemed to be more interested in the military conflict in Southeast Asia than they were in baseball, and the game would have to look to the 1970s for new life.

JOHN OLAGUES. Tulane pitcher John Olagues earned all-SEC honors in 1965 after leading the league with 136 strikeouts. The crafty right-hander helped Coach Ben Abadie's team to a 15-10 record in 1965 and 17-7 in 1966. When he was taken by the Cincinnati Reds in the third round he became the first Green Wave player to be drafted into the major leagues, but he returned to Tulane for the 1966 season. (Courtesy of Tulane University.)

JOHN ALTOBELLO. Coach Altobello's baseball teams won 4 state and 7 district championships at St. Aloysius and De La Salle, where he had a combined record of 629 wins and 202 losses (.759). His 1959 Cavalier squad is considered to be one of the finest high school teams in state history. In 25 years of coaching his teams never had a losing season. He is shown here surrounded by former players, assistant coaches, and some of the trophies this team brought home. (Courtesy of De La Salle High School.)

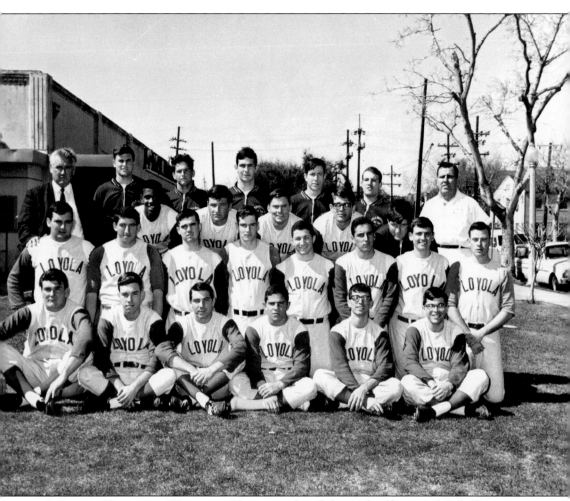

1967 LOYOLA UNIVERSITY WOLFPACK. Players are, from left to right, (front row) Billy Ferguson, Greg Roy, Stan Herwig, Frank Fortunato, Chuck Abadie, and Gerry Brechtel; (second row) Vic Hughes, Tony Branca, Howie Maestri, Connie Ryan, Argo Meza, Roy Culotta, Vic Corlock, and Billy Timken; (third row) Coach Rags Scheuermann, Charley Powell, Bob Taleancich, Robin Maginis, Howard Neumann, Irb Keller, and Trainer Tiny Tunis; (fourth row) Mark Comarda, Terry Ursin, Pat Morris, Reed Sharp, and Bruno Marasco. Vic Hughes was the son of James "Pel" Hughes, who played for the New Orleans Pelicans in 1945. Connie Ryan was the son of former major leaguer Connie Ryan. Trainer Tiny Tunis had been with the Pelicans until their demise in 1959. (Courtesy of Loyola University.)

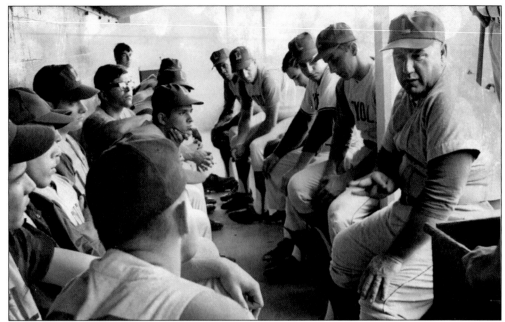

LEARN FROM THE MASTER. The Loyola University Wolfpack gathers around Coach Rags Scheuermann (far right) in the dugout at Audubon Park. During his tenure at Loyola from 1958 until 1972, Scheuermann produced 11 winning teams in 15 seasons. (Courtesy of Loyola University.)

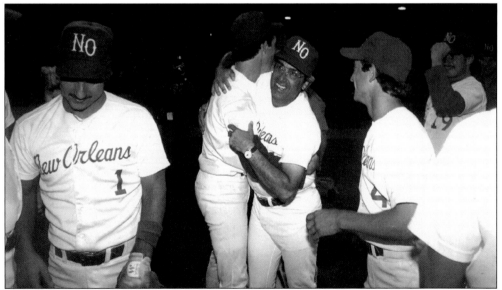

RON MAESTRI. A native of Highland Park, Illinois, Ron Maestri spent 29 years serving the University of New Orleans as head coach (1972–1985) and athletic director (1979–2000). During 13 seasons at the helm of the Privateers, Maestri compiled a career record of 518-247. He brought nine teams to NCAA tournaments, and his 1984 squad was the first team from Louisiana to reach the College World Series. In 1981 he served as head coach of the United States National team. Six players he coached, including current head coach Randy Bush, have reached the major leagues. (Courtesy of the University of New Orleans.)

SEVENTH INNING

The Comeback Begins

1970–1979

Baseball would continue its expansion phase with teams in several new cities. Pitching would again emerge as the dominant force with hurlers like Sandy Koufax and Bob Gibson setting the standard of excellence.

Tulane University, under coaches Milt Retif (1967–1974) and Joe Brockhoff (1975–1993), and the University of New Orleans, under coaches Bob Hines (1970–1971) and Ron Maestri (1972–1985), began successfully building their programs and brought both schools national recognition. While Tulane University and the University of New Orleans were taking steps to expand their baseball programs, Loyola University would once again abandon theirs. In 1972, prior to the start of the baseball season, the school announced it would eliminate their athletic programs. Despite a 1971 Wolfpack club considered to be one of the finest in the school's history, and despite protests from students, a solid program with 11 winning seasons over the past 15 years under head coach Rags Scheuermann was about to come to an end. The players removed the school's insignia from their uniforms in protest and completed the season as no-names. Coach Scheuermann, often called the Dean of New Orleans baseball, spent the next 20 years building the baseball program at Delgado Community College.

The Pelicans resurfaced as the Triple-A affiliate of the St. Louis Cardinals in the American Association, raising hopes for the return of professional baseball to the city. Games were played in the new Louisiana Superdome, which was thought to be an attraction but which turned out to be a mediocre venue for baseball. After a single season the team was relocated and New Orleans was once again without a professional baseball franchise.

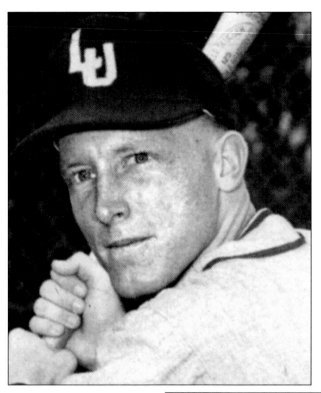

TOM SCHWANER. Tom Schwaner was born in New Orleans on March 21, 1939. After starring at shortstop for the St. Aloysius Crusaders, he received a baseball scholarship to Loyola University under Coach Lou "Rags" Scheuermann. After two seasons with the Wolfpack, Schwaner signed with the St. Louis Cardinals. (Courtesy of Loyola University.)

THE PELICANS FLY AGAIN. The New Orleans Pelicans were reborn in 1977 when the city won a franchise to operate as a St. Louis Cardinal farm club in the American Association, playing in the new Louisiana Superdome. To draw attention, small metal tokens such as the one shown here were distributed to various Mardi Gras krewes to throw to the crowds during the parade season. Among notable players to appear with the Pelicans that season were Benny Ayala and Tony LaRussa. Despite lofty ambitions, the revived Pelicans could do no better than 63-83 (.432) and did not return for the 1978 season. (Collection of the author.)

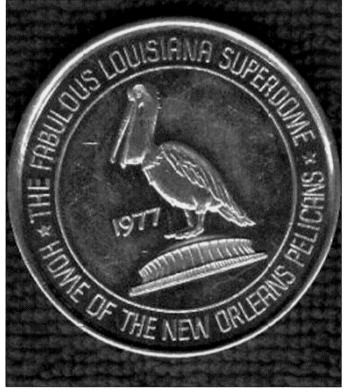

PRIVATEER PARK. Privateer Park has been the home field for the University of New Orleans since it first opened in March of 1979. The stadium underwent major renovations in 1992 in preparation for the relocation of the Triple-A Zephyrs to New Orleans. Seating capacity was increased to 4,200 and field dimensions were reset at 330 feet down the lines and 405 feet to dead center. The Zephyrs and the Privateers shared the facility for the next several years. In February of 2002, the field was renamed Maestri Field to honor 29 years of service by former head baseball coach and athletic director Ron Maestri. (Courtesy of the University of New Orleans.)

RAGS SCHEUERMANN. At the beginning of the 1972 school year, Loyola University announced that they would eliminate all of the school's athletic programs. Unlike the university's other sports, the baseball program had prospered since 1957 under the direction of Coach Louis "Rags" Scheuermann. In protest, players removed the school's insignia from their uniforms and played their final season as nomads. Coach Scheuermann affiliated himself with Delgado Community College in 1973 and built their program for the next 25 years. (Courtesy of Loyola University.)

EIGHTH INNING

The Modern Era
1980–1999

The advent of free agency brought along strikes (1981 and 1994) and work stoppages as player's salaries sky rocketed. Fans continued their on-again, off-again love affair with baseball, but college and professional football had already replaced baseball as the national pastime for most Americans. New Orleans had been the home of an NFL franchise since the early 1970s, and despite their erratic performance, the Saints were now the focus of fans' loyalties.

However, New Orleans' reputation as one of the largest American cities without professional baseball was about to come to an end. In the most recent wave of major league baseball's expansion program, Denver was awarded a franchise to be called the Colorado Rockies. This meant that the city's Triple-A club would have to relocate. In a furious and contentious series of negotiations, a group of local businessmen, headed by local attorney Robert Couhig, was successful in securing the franchise for New Orleans. The New Orleans Zephyrs were born.

The college programs at Tulane University and the University of New Orleans continued to prosper, with both schools expanding their fan-base and their facilities. Baseball was, indeed, alive and well in New Orleans.

The late 1990s saw the focus of baseball switch once again from pitching to hitting. With quality hurlers in short supply, the home run once again brought fans back to the game. The Cardinals' Mark McGuire and the Cubs' Sammy Sosa not only chased Roger Maris and Babe Ruth's records, but obliterated them, only to have San Francisco's Barry Bonds trample them three seasons later. Cal Ripken broke Lou Gehrig's mark for consecutive games. Records that had stood for decades were falling to a new generation of ball players.

AN ADOPTED SON. Although Ron Swoboda was born in Baltimore, Maryland, in 1944, he has made his home in New Orleans when he accepted a position as sports director for the local ABC affiliate. Signed by the Mets as an amateur free-agent in 1963, he spent a year in the minors before making his debut as a 20-year-old rookie with the hapless New York Mets on April 12, 1965. While Swoboda pounded out 19 home runs, the Mets finished in tenth place. On May 23, following a three-base error and an unsuccessful at-bat, Swoboda got his right foot stuck in his batting helmet. While many reports have him taking his position in right field with the batting helmet still attached, he was actually ordered to the clubhouse by manager Casey Stengel. The Mets floundered in ninth or tenth place in the National League East until 1969, when the "Miracle Mets" won the pennant and faced the Baltimore Orioles in the World Series. It was Swoboda's dramatic diving catch in the ninth inning of game four, known to a new generation of baseball fans as "The Catch," that provided the Series' most memorable moment, shown here. Over nine seasons Swoboda batted .242 with 73 home runs and 344 RBIs. He retired in 1973 after two seasons with the New York Yankees. His post-baseball career has included activities as varied as the restaurant business (with former teammate Ed Kranepool), freelance writing for magazines and newspapers, and even a guest shot on *Everybody Loves Raymond* in 1999 (as himself). Swoboda currently works with the New Orleans Zephyrs organization and is featured as their on-air radio and television broadcaster. (Collection of the author.)

THE MAN WITH THE GOLDEN SPIKES. Augie Schmidt was an outstanding infielder with the University of New Orleans Privateers (1980–1982). His consistent offensive production and steady glove work earned him the Golden Spikes Award, presented annually to the best collegiate baseball player in the country. Schmidt batted .300 or better in each of his three seasons at UNO, and he is ranked among the school's all-time career producers in walks (second, 165), runs (fourth, 184), home runs (fifth, 30), RBIs (sixth, 162), slugging percentage (seventh, .580), and triples (ninth, 10). He signed with the Toronto Blue Jays organization in 1982 and assigned to the team's Kinston club in the Carolina League. Schmidt enjoyed two years with Knoxville in the Southern League but retired after the 1986 season. (Courtesy of the University of New Orleans.)

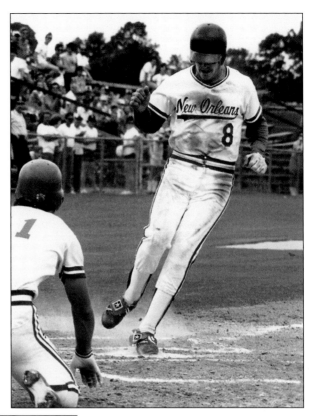

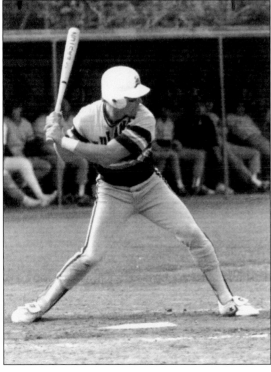

DAN WAGNER. An excellent student-athlete, Dan Wagner was an offensive standout at Tulane (1983–1986) under head coach Joe Brockhoff. An outstanding hitter, Wagner holds career records for average (.380), runs (284), triples (16), and total bases (619). He also ranks in the top 10 for nearly every offensive category. His senior season in 1986 was among the finest in school history—177 total bases, 96 hits, 26 doubles, 5 triples, 76 runs, and a .694 slugging percentage—all of which are still single season records at Tulane. Wagner was drafted in 1986 by the Chicago White Sox in the 16th round. He enjoyed four years in the minor leagues, his best year being 1988 with Tampa in the Florida State League (.278 BA, 5 HR, 21 RBI). He retired after the 1990 season and still makes his home in the New Orleans area. (Courtesy of Tulane University.)

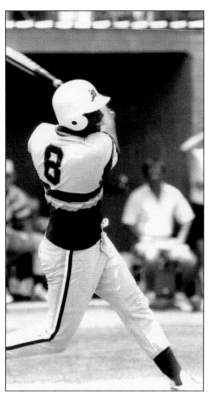

EMMANUEL "TOOKIE" SPANN. New Orleans native Emmanuel "Tookie" Spann was a star prep athlete at Brother Martin High School and was a member of their powerhouse 1984 Crusader nine that was widely considered to be one of the best high school teams in New Orleans history. Spann was a two-sport athlete, excelling at both football and baseball for the Green Wave. He was co-captain of Coach Mack Brown's 1986 and 1987 football teams. But Spann was a baseball player at heart. During his four-year career at Tulane (1985–1988), Spann piled up offensive statistics that helped Coach Joe Brockhoff's club to three consecutive NCAA Regional appearances (1986–1988) and an overall record of 163-73 (.691). He ranks third in RBIs (259); fourth in slugging percentage (.657) and sacrifice flies (16); fifth in batting average (.361), home runs (52), and walks (159); sixth in total bases (470); eighth in doubles (52) and runs (204); and ninth in hits (258). Spann was selected in the third round of the 1988 major league draft by the Detroit Tigers. He spent six years in the minor league ranks, enjoying his best year in 1992 with High Desert in the California League where he hit .265 with 19 home runs and 103 RBIs. He retired from playing after the 1993 season. (Courtesy of Tulane University.)

GREG HIBBARD. Born in New Orleans on September 13, 1964, Greg Hibbard attended Harrison Central High School in Gulfport, Mississippi, where he was drafted in the eighth round of the 1984 draft by the Houston Astros. Hibbard opted for the University of Alabama. He was selected in the 16th round of the 1986 draft by the Kansas City Royals, laboring in the Royals organization until he was traded to the Chicago White Sox. He made his major league debut with the Chicago White Sox on May 31, 1989. He played for the Sox (1989–1992), the Chicago Cubs (1993), and the Seattle Mariners (1994). His best years were 1990 (14-9, 3.16 ERA) and 1991 (11-11, 4.31 ERA), but by 1994 he was traded to the Seattle Mariners and retired after the end of the season. Hibbard became a footnote in baseball history on June 29, 1991, when the Twins' Kirby Puckett gathered his 1,500th career hit off Hibbard. After several seasons as the pitching coach for the Schaumberg Flyers and the Joliet Jack-Hammers, Hibbard became the pitching coach in the Cleveland Indians' Mahoning Valley Class-A club in 2003. (Courtesy of the Chicago White Sox.)

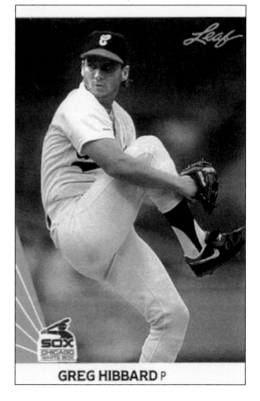

GREG HIBBARD P

WILL CLARK. Born in New Orleans, Clark graduated from Jesuit High School and went on to become an All-American at Mississippi State. He played a starring role on the 1984 Olympic team. The following year he won the Golden Spikes Award, given annually to the country's top collegiate player. Selected with the second overall pick in the June 1985 draft by the San Francisco Giants, Clark wasted little time acclimating himself to life as a professional. Just two days after signing with the Giants, Clark homered on his first swing in the minor leagues. Less than 10 months later, he opened the season as the Giants' regular first baseman. Clark connected for a round tripper against future Hall of Fame pitcher Nolan Ryan in his first major league at-bat on April 8 and finished his rookie season with a .287 batting average and 11 home runs. He became quite a durable player after his rookie season injury, setting a San Francisco record with 320 consecutive games played from September 1987 through August 1989. However, a string of injuries cut into his playing time in the early 1980s and diminished his production. (Courtesy of the New Orleans Zephyrs.)

BRIAN TRAXLER. His 15 home runs during the 1986 season with the UNO Privateers told head coach Tom Schwaner that he had an offensive powerhouse on his team. During the following season, Traxler terrorized opposing pitchers for 20 home runs, 78 RBIs, and 161 total bases on his way to a .676 slugging percentage. The 1987 club would go 44-19 and earn an invitation to the NCAA South II Regional tournament. Traxler is the UNO career leader in home runs (49), RBIs (206), and total bases (438). He also ranks among the team's top ten producers for seven other offensive categories. He was signed by the Los Angeles Dodgers organization in 1988 and spent the next seven years with four different minor league teams, retiring from baseball after the 1997 season. (Courtesy of the University of New Orleans.)

TED WOOD. Ted Wood did not look like a hitting machine until he stepped onto the field at the University of New Orleans in 1986. Three years later he owned the Privateer career records for batting average (.380) and runs (230). Wood also ranks among the school's top hitters in total bases (second, 413), home runs (third, 34), hits (third, 250), slugging percentage (third, .628), and walks (fourth, 155). Along with UNO teammate Joe Slusarski, he was named to the 1988 gold-medal-winning Olympic team, batting .474 with 8 RBIs. (Courtesy of the University of New Orleans.)

JOE SLUSARSKI. In two seasons with the University of New Orleans Privateers (1987–1988), right-hander Joe Slusarski compiled a 26-7 record. In his senior year he established single season records for innings pitched (160.1) and strikeouts (146). Following the team's appearance in the 1988 NCAA Central Regional tournament, he was named to the 1988 gold-medal-winning Olympic team, along with UNO teammate Ted Wood. Slusarski was drafted in the second round by the Oakland Athletics. During two seasons in the minors (1989–1990) he compiled a record of 23-20 and was called up the following season by the Athletics. He made his major league debut on April 11, 1991, against the Minnesota Twins, winning his first outing. After stints with the A's (1991–1993) and the Milwaukee Brewers (1995), he returned to New Orleans with the Zephyrs (1995–1996, 1998–1999) and was a member of the Zephyrs Triple-A World Series Championship squad. (Courtesy of the University of New Orleans.)

CHRIS SABO. Chris Sabo was an early star for the Zephyrs, eventually being called up by the Cincinnati Reds in 1988 when he made his debut on April 4, 1988, for manager Pete Rose. He would go on to be named Rookie of the Year and won a spot on the 1988 All-Star team. He would revisit the All-Star squad in 1990 and 1991. An injury-riddled 1993 season saw Sabo traded to Baltimore Orioles in 1994, but he never fully recovered, playing in only 68 games that year. He was then traded to the Chicago White Sox and the St. Louis Cardinals in 1995 before returning to the Reds in 1996 for 54 games in his final season. He is currently the manager of the Florence Freedom, Cincinnati's affiliate in the Frontier League. (Courtesy of the New Orleans Zephyrs.)

TURCHIN STADIUM. Dedicated in March of 1991, Turchin Stadium is one of the finest on-campus baseball facilities in the South. Tulane has been playing within 500 feet of its current location for the past 40 years. With recent improvements to the facility, including lights (1991), new dugouts (1997), additional seating (1997), and the Sofio Hitting Facility (1999), the stadium has also been the venue for numerous conference and NCAA tournaments. In addition, the Green Wave draws an average of 3,200 fans per game, ranking the program among the top 10 nationally in attendance. (Courtesy of Tulane University.)

SCOTT TAYLOR. After breaking in with Williamsport (Eastern League) in 1989, Scott Taylor traveled the minor league circuit for four years before coming to the New Orleans Zephyrs in 1993. For the next three seasons the big right-hander from Kansas would compile a record of 27 victories and 18 losses with a 3.38 ERA. He threw a no-hitter on August 12, 1994 in a 5-0 victory over Pacific Coast League rival the Buffalo Bisons.

MARSHALL BOZE. Another early star with the Zephyrs when they were an affiliate of the Milwaukee Brewers, right-hander Marshall Boze rose through the Brewers' organization and landed in New Orleans for three seasons (1994–1996). During his tenure with the Zephyrs, Boze compiled a record of 13 wins and 22 losses. He was the first native of Alaska to play in the majors. Boze still appears on the mound, most recently pitching at age 41 for the Peninsula Oilers back home in Alaska. (Courtesy of the New Orleans Zephyrs.)

MIKE MATHENY. Mike Matheny is one of a string of strong catchers who played for the New Orleans Zephyrs. As a member of the team from 1994 until 1996, Matheny was better behind the plate than in front of it, batting .266 with 8 home runs and 31 RBIs combined in his three years with the Zephyrs. He played on and off with the Brewers from 1994 to 1998, moving to the Toronto Blue Jays in 1999. He found a home with the St. Louis Cardinals in 2000, becoming their regular catcher, a position he still currently holds. (Courtesy of the New Orleans Zephyrs.)

A SHRINE IN THE MAKING. In 1996, while the New Orleans Zephyrs were drawing 180,023 fans in their fourth year at the University of New Orleans' Privateer Park on the school's lakefront campus, construction crews were hard at work erecting the Zephyrs' new home, Zephyr Stadium. One of the finest facilities of its kind in the country, Zephyr Stadium has also played host to President Bush, the Traveling Vietnam Veterans Wall, and the Cirque du Soliel, as well as countless concerts, picnics and, of course, baseball games. Here we see construction in progress along the third base side of the stadium. Built along Airline Highway in Metairie (a suburb of New Orleans), the ballpark is affectionately known as the "shrine on Airline." (Courtesy of the New Orleans Zephyrs.)

HOME RUN COMBO. The combination of Jason Sparks (left) and Chad Sutter (right) belted out 124 career home runs between 1996 and 1999. Sparks holds the Tulane single-season record for round-trippers, hitting 30 in 1998, breaking the single-season mark of 23 posted by Sutter the year before. (Courtesy of Tulane University.)

CHAD SUTTER. The son of major league pitcher Bruce Sutter, Chad was one of the best power hitters ever to play for Tulane. From 1996 through 1999 he was three times All-Conference in Conference USA. From his first season, when he was named Freshman of the Year in CUSA, through his senior year, when he was named Player of the Year in CUSA, Sutter was the first player in conference history to earn both honors during his career. His 75 home runs and 280 RBIs remain Tulane career records. His standout season came in 1999, as the right-handed catcher scorched opposing pitchers for 94 hits, 23 home runs, 87 RBIs, and 175 total bases on his way to a .393 average and All-American honors from *College Baseball Insider*, *Collegiate Baseball*, *Baseball Weekly*, and the National Collegiate Baseball Writers Association. Sutter was drafted by the New York Yankees in the 23rd round and played in their organization until 2001 when he returned to his alma mater, first as a graduate assistant, then as pitching coach for the 2002 and 2003 seasons. He left Tulane after the close of the 2003 season to accept a coaching position with UNLV under former Tulane assistant Buddy Gouldsmith. (Courtesy of Tulane University.)

RANDY KNORR. The California native first broke into professional baseball with Medicine Hat in the Pioneer League in 1986 and spent the next few years bouncing around the minors until he made his debut on September 5, 1991, with the Toronto Blue Jays near the end of the season. He finally received more playing time in 1993 and actually appeared in one game of the 1993 World Series against Philadelphia. By 1997, he was back in the minors with the New Orleans Zephyrs where he batted .238 with 5 home runs and 27 RBIs. He is currently with the Montreal Expos organization. (Courtesy of the New Orleans Zephyrs.)

CARLOS GUILLEN. This native of Venezuela was a member of the 1997 and 1998 New Orleans Zephyrs. He was one of three players involved in the Randy Johnson trade that sent Guillen from the Astros to the Seattle Mariners in July of 1998. With Alex Rodriguez firmly in place at shortstop, Guillen struggled at second and third base until Rodriguez moved to Texas after the 2000 season. Since then Guillen has become an anchor at shortstop for the Mariners. (Courtesy of the New Orleans Zephyrs.)

111

LOUISIANA PITCHMAN. Then Governor Edwin Edwards joins other local political leaders at the dedication of Zephyr Field on April 11, 1997, before a sellout crowd of 10,366 fans. The governor threw out the ceremonial first pitch. The Zephyrs would christen the field with an 8-3 victory over Oklahoma City, just eight days after becoming affiliated with the Houston Astros. The Zephyrs would draw 517,200 fans to the new facility in 1997—now dubbed the "shrine on Airline" for its location on Airline Highway in the suburbs of New Orleans. The ballpark is a model of successful sports management. Edwards has not fared so well. He was convicted in 2000 on 17 counts of racketeering, money laundering, and conspiracy after two previous trials and 22 grand jury investigations. (Courtesy of the New Orleans Zephyrs.)

ROY OSWALT. This native of Kosciusko, Mississippi, has been in the Astros' organization since 1997. His performance with the New Orleans Zephyrs was good enough to have him called up to the Houston club, where he went 14-3 with 4.54 ERA in 28 appearances. His second season saw his record climb to 19-9 with a 3.31 ERA and firmly placed Oswalt in the Astros' starting rotation. (Courtesy of the New Orleans Zephyrs.)

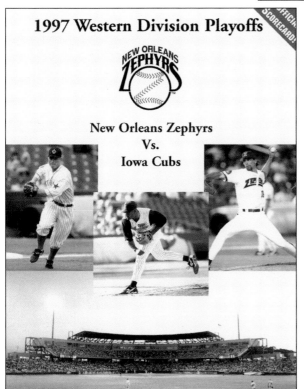

ZEPHYRS MAKE THE PLAYOFFS. Just five years after relocating to New Orleans from Denver, the Zephyrs enjoyed a break-out season, drawing 507,164 fans during the year. On September 5, 1997, the Zephyrs fell to the Iowa Cubs in the franchise's very first playoff game. The scorecard shown here was from that game. They would rebound the following season, not only breaking another attendance record by drawing 519,584 fans, but also by winning the Pacific Coast League pennant and the Triple-A World Series. (Collection of the Author.)

RICK JONES. This native of North Carolina has been a success throughout his 22-year coaching career, taking his teams into the post-season in all but two years (1988 and 1995). A veteran of three NAIA World Series appearances, he helped the Green Wave make their first appearance in the NCAA College World Series in Omaha in 2001. His career record at Tulane stands at 426-204, with eight consecutive post-season NCAA appearances, making Jones one of the most successful coaches in the history of Tulane athletics. For his career he is 702-297. (Courtesy of Tulane University.)

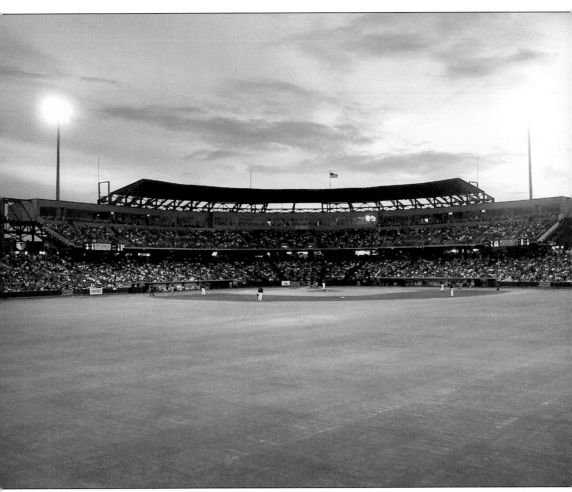

ZEPHYR FIELD. In 1993, New Orleans baseball fans were able to celebrate the return of professional baseball to the city. When Denver was granted an expansion franchise for the Colorado Rockies, the Triple-A Zephyrs were required to relocate. New Orleans won over several other cities vying for the Milwaukee Brewers' Triple-A Pacific Coast League affiliate. Playing their first season at Privateer Park on the lakefront campus of the University of New Orleans, the Zephyrs finished the 1993 season at 80-64, good enough for second place in their division. They drew 161,846 fans that year, and by 1997 the team was drawing over 517,000 fans to their new facility. With a new stadium and a new affiliation with the Houston Astros, the club would go all the way in 1998, winning the Pacific Coast League title and the Triple-A World Series. They would repeat as Pacific Coast League champs in 2001. Zephyr Field remains a popular facility, hosting NCAA baseball tournaments and intrastate rivalries between Tulane University, Louisiana State University, the University of New Orleans, and the University of Louisiana–Lafayette. (Courtesy of the New Orleans Zephyrs.)

LANCE BERKMAN. Houston native Lance Berkman first made headlines with nationally-ranked Rice University before being drafted by Houston Astros as their number one draft pick (16th overall) in 1998. He displayed above average power in three seasons in New Orleans (1998–2000) and was a member of the Zephyrs' 1998 Triple-A World Series and PCL championship teams. In addition to being a team leader on the field, Berkman showed his lighter side by frequently impersonating the Zephyrs' mascot and dancing on the dugout roof. He also once took batting practice in a sumo wrestler's costume. It was not enough to dissuade the Astros from trading Roger Cedeno to the Detroit Tigers to make room for Berkman in left field for a 2001 edition of the Astros that would include Craig Biggio and Moises Alou. He was a member of the National League All-Star team in 2001 and 2002. (Courtesy of the New Orleans Zephyrs.)

TONY PEÑA. A former five-time All-Star (1982, 1984, 1985, 1986, 1989), Tony Peña brought his skills as a catcher for 18 years in the majors to the dugout when he assumed control of the New Orleans Zephyrs in 1999. His first team (1999) finished fourth with a record of 53-85 in a season where Houston was devastated with injuries and had to strip the Zephyrs' roster for players. In his second season (2000), Peña piloted the club to a third place finish, going 68-74. His banner year was 2001, putting up an 82-57 record and finishing as co-champions of the Pacific Coast League with Tacoma in a season cut short by the tragedy of September 11. Nevertheless, it earned Peña his shot at managing in the big leagues with the Kansas City Royals. (Courtesy of the New Orleans Pelicans.)

JOSE CABRERA. A native of the Dominican Republic, Jose Cabrera was a member of the New Orleans Zephyrs from 1997 through 2000. The right-hander made his major league debut on July 15, 1997, with the Houston Astros at the age of 28 after laboring for six seasons with a variety of minor league clubs. During his six years in the majors, Cabrera has compiled a record of 19-17, with 4 saves and a 4.95 ERA. He is currently pitching for the Philadelphia Phillies. (Courtesy of the New Orleans Zephyrs.)

JAMES JURRIES. From 1999 through 2002, James Jurries set a standard of excellence in the Tulane University baseball program. As a true freshman, he set single season records for total bases (194) and runs (90), while hitting 20 home runs and 79 RBIs. He was named Conference USA Freshman of the Year and First Team All-CUSA. Jurries was also tapped for All-American honors by *Baseball America, Baseball Weekly, College Baseball Insider, Collegiate Baseball,* and the National Collegiate Baseball Writers. After solid seasons in 2000 and 2001 Jurries had an awesome year in 2002, posting a .400 batting average with 20 home runs, 77 runs, 96 hits, 180 total bases, a .750 slugging percentage, and 30 stolen bases. He was named the team's Most Valuable Player and CUSA Player of the Year. Jurries was again selected as an All-American by *Baseball America, Collegiate Baseball,* and the National Collegiate Baseball Writers. He was taken by the Atlanta Braves organization in the June 2002 draft, where he made the transition to wooden bats without a hitch, homering in his first professional at bat.(Courtesy of Tulane University.)

BARTH MELIUS. New Orleans native Barth Melius was a local high school favorite when he signed with Tulane University. He pitched for four seasons (1998–2001) for the Green Wave, including his senior year when he went 10-1 (.909) and helped lead the team to their first-ever appearance in the College World Series in Omaha. Melius was a master of off-speed, unusually propelled pitches that more often than not left opposing batters totally frustrated. (Courtesy of Tulane University.)

Ninth Inning

Another New Century

2000–Present

While major league baseball was considering contraction, revenue sharing, and a host of other changes, some things remained constant—in 2000 the Yankees won the American League East, the American League pennant, and then the World Series. On the other hand, baseball was alive and well in New Orleans at the turn of the 21st century.

The New Orleans Zephyrs continued to contend for the Pacific Coast League title year after year, winning their second pennant in 2001. The Houston Astros' Triple-A affiliate continued to send strong, talented players to the big leagues. Fan attendance is once again on the rise as entire families have discovered the simple pleasure of watching baseball at the ball park instead of on television.

The collegiate programs at Delgado Community College, Loyola University, the University of New Orleans (UNO), and Tulane University continue to prosper and draw more fans. Tulane went to the College World Series in Omaha for the first time in 2001 and set an NCAA attendance record in a game with LSU on April 10, 2002, when 27,673 crowded into the Louisiana Superdome to perpetuate a rivalry that has existed since 1888.

RANDY BUSH. After hitting .454 for Miami-Dade Community College in 1978, the Dover, Delaware native transferred to the University of New Orleans in 1979. In his only season with the Privateers, Bush batted .369 with 18 home runs, 8 triples, and 77 RBIs, leading his team to the Sun Belt Conference championship. He was a second-round draft pick of the Minnesota Twins in June and reported to Orlando in the Southern League. From 1979 to 1981, Bush hit .231 with 13 home runs and 67 RBIs. After beginning the 1982 season with Toledo in the International League, he was called up to Minnesota and made his major league debut on May 1, 1982. Bush was also on the Twins' two World Series championship teams in 1987 and 1991. After retiring, he returned to UNO to receive his degree in December of 1994. Bush became the head baseball coach on June 17, 1999, and in four seasons his teams have compiled a record of 117-117. (Courtesy of the University of New Orleans.)

NOT BUSH LEAGUE. On April 25, 2001, President George W. Bush visited New Orleans to deliver a speech. The event was held at Zephyr Stadium and afterwards the President shook hands with the crowd. Among those in attendance was the University of New Orleans baseball team, shown here greeting the President. Prior to entering politics, the President was the principal owner of the Texas Rangers franchise and remains a huge baseball fan. (Courtesy of the University of New Orleans.)

JAKE GAUTREAU. Slugger Jake Gautreau (far left) is shown being congratulated by his Tulane University teammates following his fifth-inning solo home run against Nebraska, the school's first victory at the 2001 College World Series. A veteran of the 2000 National team, where he batted .348, Gautreau was drafted in the first round of the 2001 major league draft by the San Diego Padres. (Courtesy of Tulane University.)

TULANE INFIELD. Flanking pitcher Chris Kline are the members of Tulane's 2001 infield, from left to right, James Jurries (3B), Tony Giarratano (2B), Andy Canizzaro (SS), and Jake Gautreau (1B). As a defensive unit these young men helped the team achieve a .962 fielding average. Second baseman Andy Canizzaro performed 540 assists during his four year career, second in school history. (Courtesy of Tulane University.)

ANDY CANIZZARO. A native of the New Orleans area, Andy Canizzaro brought the whole package to the Tulane Green Wave in 1998—hitting, fielding, and base-stealing. At the time of his graduation in 2001, Canizzaro held school records for games played (248), at-bats (1,030), hits (350), doubles (85), stolen bases (128), sacrifice flies (21), and sacrifice hits (25). He was drafted in the seventh round in 2001 by the New York Yankees. (Courtesy of Tulane University.)

2001 NCAA Super Regional. The very first intercollegiate sports contest in the state of Louisiana was a baseball game between Tulane University and LSU on January 7, 1888. One hundred thirteen years later the rivalry was still going strong when they met in the 2001 NCAA Super Regional at Zephyr Field in Metairie, Louisiana. Tulane dropped the Friday night opener 4-3 in a 13-inning thriller. The score was tied in the seventh inning on an RBI single by New Orleans native Wally Pontiff, which plated LSU's David Raymer. Raymer would hit a sacrifice fly in the top of the 13th to score Chris Phillips. Tulane answered the LSU challenge on Saturday afternoon behind the pitching of Nick Bourgeois and the hitting of Andy Canizzaro. Bourgeois hurled six scoreless innings and freshman Joey Charron earned the save by retiring seven of the nine batters he faced. Canizzaro went 3-for-5 with a single, double, and home run. Tulane won the game 9-4 and the series was tied. The Sunday afternoon game saw Tulane southpaw Beau Richardson throw a complete game victory, scattering seven hits, allowing a single walk, and setting a career mark of eight strikeouts to seal the victory 7-1. Tulane exploded for six runs in the fourth inning and never looked back, winning the decisive game. (Courtesy of Tulane University.)

ON HALLOWED GROUND. Following their dramatic victory over intra-state rival LSU in the NCAA Super Regional, the Tulane Green Wave found themselves in Omaha, Nebraska, for the 2001 College World Series for the first time in the school's history. Walking across Rosenblatt Field are, from left to right, Turner Brumby, James Jurries, Matt Mann, Aaron Feldman, James Burgess, Michael Aubrey, Andy Canizarro, and Jon Kaplan. (Courtesy of Tulane University.)

AN NCAA RECORD. Ever since Tulane and LSU played their first baseball game on January 7, 1888, the rivalry has been one of the most enduring and popular in Louisiana sports history. On April 10, 2002, in the Louisiana Superdome, fans set an NCAA single-game attendance record as 27,673 faithful were on hand to watch the LSU Tigers defeat Tulane by a score of 9-5. This shattered the former regular season record of 21,043, set by TCU and Texas in 1996. It also surpassed the all-time college record of 24,859 set during the 1999 College World Series in Omaha. (Courtesy of Tulane University.)

FRESHMAN PHENOM. Michael Aubrey embodies the true spirit of the student-athlete at Tulane University. He was named to the Conference USA Honor Roll in 2001 as well as being selected CUSA Freshman Player of the Year. The versatile Shreveport native also started all 69 games as a true freshman—32 games in left field, 24 as designated hitter, 13 as pitcher, 12 at first base, and 1 in right field—batting .361, with 13 home runs and 69 RBIs. Aubrey made 17 appearances on the mound posting a 3-1 record, with a 5.15 ERA. His performance resulted in being named National Freshman of the Year by *Baseball America, Collegiate Baseball,* and *The Sporting News,* while also earning Freshman All-American honors from *Baseball America, Collegiate Baseball,* and *Baseball Weekly.* (Courtesy of Tulane University.)

EVERYBODY'S ALL-AMERICAN. Aubrey continued his collegiate career while also playing for the United States National Team during the summer. In 2002 he captured the Team USA Triple Crown in batting average (.405), home runs (5), and RBIs (26). He became the first member of the National Team to bat .400 since the program switched to wooden bats in 2000. But Michael wasn't done. During his junior year at Tulane in 2003, Aubrey tore up opposing pitchers, batting .420 with 18 home runs and 79 RBIs. He was voted the Conference USA Player of the Year and named to All-American teams by the American Baseball Coaches Association, *Baseball America, Collegiate Baseball, Sports Weekly,* and the National Collegiate Baseball Writers Association. During his career at Tulane he batted .369, with 36 home runs and 197 RBIs. He also posted an 11-2 pitching mark with a 4.82 ERA during the 2001 and 2002 seasons. Selected in the first round of the June 2003 draft by the Cleveland Indians, Aubrey tore up opposing pitchers as first baseman for the Lake County Captains in Class-A ball, batting .348 in 38 games, with 5 home runs and 19 RBIs. (Collection of the author.)

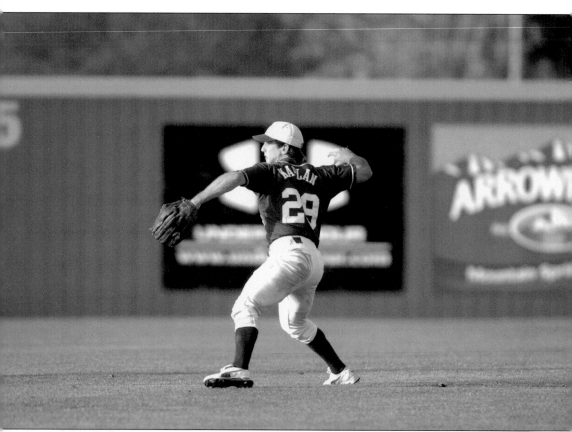

JON KAPLAN. A walk-on who spent most of his freshman year as a bullpen catcher, Jon Kaplan spent the next three years leading the Tulane Green Wave to new heights. A native of Chesterfield, Missouri, Jon played with enthusiasm and attitude. There is a popular saying around Turchin Stadium: two-thirds of the world is covered by water, the rest is covered by Jon Kaplan. Known for his speed and range in chasing down fly balls from his position in center field, Kaplan also used his speed on the base paths. For two years Kaplan was the lead-off hitter and once on base was always a threat to steal. Urged on by the sounds of "Go, Johnny, Go! Go!" from Chuck Berry's "Johnny B. Goode," Kaplan stole 107 bases in 126 attempts in three years at Tulane. Selected by the Arizona Diamondbacks in the 12th round of the June 2003 draft, Kaplan reported to their Missoula club (Pioneer League) where he batted .280, with 4 home runs and 31 RBIs during a 60 game slate. He also stole 9 bases in 13 attempts. (Courtesy of Tulane University.)

WALLY PONTIFF JR. A four-year letterman at Jesuit High School where he batted .429 with 15 home runs and 64 RBIs, earning all-district, all-metro, and all-state honors, Wally Pontiff was the complete package. A true student-athlete, he enrolled at LSU to play for Coach Skip Bertman. His freshman year Pontiff batted .347 in 61 games with 2 homers and 45 RBIs. He was named the Most Valuable Player in the Southeastern Conference (SEC) Tournament, hitting .615 with 7 RBIs and a grand slam in the championship game over Florida. During the College World Series he batted .214 with a double, an RBI, and 3 runs as LSU captured the National Championship in Omaha. Pontiff started all 67 games of the 2001 season, matching his 2000 batting average of .347 with a triple, 7 homers, and 58 RBIs. He was LSU's leading hitter in their unsuccessful NCAA Super Regional match against Tulane. In 2002 Captain Pontiff continued to lead his tigers with a .339 average in 65 games, in walks (48), and on-base percentage (.443). LSU once again went to the Houston NCAA Super Regional but fell to the Rice Owls. Then, on July 24, 2002, baseball fans across the state were shocked to learn that the 21-year old Pontiff died in his sleep from an undetected heart abnormality. The outpouring of grief was statewide. Testimonials and memorials poured in from across the country. LSU retired his number. The Tiger Athletic Foundation has established a scholarship in his name. The Metairie playground where he grew up was renamed in his honor. Wally Pontiff's life was cut short, but his spirit lives on. (Courtesy of Louisiana State University.)

OZZIE SMITH. Newly elected to the Hall of Fame, former St. Louis Cardinal shortstop Ozzie Smith visited New Orleans on April 25, 2003, to throw out the first pitch at Zephyr Stadium versus Oklahoma City. (Courtesy of the New Orleans Zephyrs.)

ARTHUR O. SCHOTT. A virtual treasure trove of baseball facts, statistics, and history, Arthur Schott is Louisiana's Official Baseball Historian. Although for many years he ran his family's business, Schott Meats (formerly located on the corner of Poydras Street and Claiborne Avenue across the street from the Superdome), Schott also wrote baseball columns for the *Times-Picayune* under the byline A Schott From The Bleachers. His New Orleans home is packed wall to wall with baseball books, pictures, and memorabilia acquired over the years. A life-sized figure of Babe Ruth stands in one corner. A lifelong statistician, Schott was a founding member of the local chapter of the Society of American Baseball Research (SABR) and is a frequent guest on radio talk shows when the topic of baseball is being covered. (Courtesy of Arthur O. Schott.)